T0366823

SCENE CHANGE 2

EXCEPTIONAL! PERSUASIVE! With over three decades of experience in the nonprofit sector, Alan's commitment to driving charitable impact within the arts community is truly commendable. His insightful and thought-provoking writings underscore his dedication to uplifting the underserved and marginalized, with an unwavering focus on equity and meaningful action. Alan's ability to engage and captivate through his writing is a testament to his engrossing style and deep expertise. Having had the privilege to work alongside him, I've witnessed his remarkable talent in poking bears, challenging the status quo, and inciting positive change. His leadership acumen shines through as he navigates both large and small organizations, consistently demonstrating his capacity to galvanize teams towards mission-driven success. In a world where impactful communication is paramount, Alan's unique approach to advocacy and his passion for transformation make him an invaluable asset to any mission-focused initiative. His transformative prowess and commitment to making a difference are truly remarkable.

Mark Walmsley, FRSA FCIM, Arts & Culture Network

A VISIONARY! In the sea of voices championing for the arts, Alan Harrison's voice is unmissable. I continue to be struck by his unparalleled passion and relentless pursuit of change within the nonprofit arts sector. His unpretentious and comical demeanor bring clarity of thought and a fearless commitment to issues like elitism, diversity, equity, and inclusion within arts organizations. Whether you admire or challenge his viewpoints,

Alan's persuasive influence cannot be easily dismissed. Perhaps his most significant impact is his ability to inspire those around him to entertain new perspectives and aim for a greater, more inclusive future.

Sarah Hunt, Accelerate Social (Former General Manager, National Theatre of Great Britain)

HE GETS IT! I've been inspired by our conversations about nonprofit management as well as everything he's written. He wants to make organizations better, more effective, and has the experience and wisdom to know how to do exactly that. I respect his work and learn something from him with every interaction.

Cynthia Setel, Nonprofit Change Agent/Consultant

In one's professional life, one hopes to rely on a short, but extremely important, list of people as go-tos — the leaders, thinkers and achievers who represent such depth and breadth of knowledge, wisdom, and experience, not to mention practical and transferable skills, that you cherish them simply for being on that short, but extremely important, go-to list. For me, such a person is Alan Harrison. In the years that I have known Alan, I have learned more about running arts organizations, particularly if not exclusively not-for-profit arts organizations, than most people learn in a two- or three-year MA arts administration program — and as I've taught in one such program, I can actually compare his skills to curricula and confirm that Alan is, indeed, a master class in his field.

Leonard Jacobs, Executive Director, Jamaica Center for Arts and Learning, Inc.

Review for *Scene Change: Why Today's Nonprofit Arts Organizations Have to Stop Producing Art and Start Producing Impact*

With passion and humor, Alan Harrison challenges virtually every assumption under which nonprofit arts organizations have operated for the last 50 years. But while he challenges sacred cows left and right, don't be fooled into thinking he is a cynic because, underneath it all, this fervent manifesto reveals that he is a cockeyed optimist with a breathtaking vision of how arts organizations should operate over the next 50 years.

Robert Wildman, Winthrop University

SCENE CHANGE 2

The Five REAL Responsibilities of
Nonprofit Arts Boards

First Book in This Series

Scene Change: Why Today's Nonprofit Arts Organizations Have to Stop Producing Art and Start Producing Impact

ISBN 978-1803414461

SCENE CHANGE 2

The Five REAL Responsibilities of Nonprofit Arts Boards

Alan Harrison

Edited by Michelle Auerbach

CHANGEMAKERS
BOOKS

London, UK
Washington, DC, USA

CollectiveInk

First published by Changemakers Books, 2024
Changemakers Books is an imprint of Collective Ink Ltd.,
Unit 11, Shepperton House, 89 Shepperton Road, London, N1 3DF
office@collectiveinkbooks.com
www.collectiveinkbooks.com
www.changemakers-books.com

For distributor details and how to order please visit the 'Ordering' section on our website.

Text copyright: Alan Harrison 2023

ISBN: 978 1 80341 698 4
978 1 80341 713 4 (ebook)
Library of Congress Control Number: 2023949552

A CIP catalogue record for this book is available from the British Library.

Design: Lapiz Digital Services

UK: Printed and bound by CPI Group (UK) Ltd, Croydon, CR0 4YY
Printed in North America by CPI GPS partners

We operate a distinctive and ethical publishing philosophy in
all areas of our business, from our global network of authors to
production and worldwide distribution.

Contents

The current state of zeal among nonprofit arts boards, as demonstrated in a three-line play:

Chauncey and Edgar are sitting on a park bench.

Chauncey: Edgar, I'm against the war.
Edgar: But, Chauncey, we're all against the war.

Chauncey: Yes, but I wrote a letter.

Preface

In the runup to the release of the first book in this series (*Scene Change: Why Today's Nonprofit Arts Organizations Have to Stop Producing Art and Start Producing Impact*), we conducted a survey asking board members of varied nonprofit organizations three simple questions.

1. What is your board of directors' single most important responsibility?
2. What is *your* single most important responsibility to the board of directors?
3. If you had to pick one, what single responsibility of your board of directors is currently lacking?

We asked for only one answer per question and a maximum of six words per answer to allow us to categorize the responses.

The research was not as complete as I would have preferred, but a steady progression of answers provided key takeaways. On the first question, the most popular answer was "raising money." On the second question, the most popular answer, by a hair, was "raising money." And on the third question, the most popular answer was "raising money."

The least popular answer among the respondents for the first question was "advocacy." It was the same for the second. And the third.

You can't raise money without being a zealous advocate. If you try to raise money before advocating, no one will know why it's important. It's like screaming at Giannis Antetokounmpo to make a basket … after which you throw him the ball.

And yet, countless board members have been so indoctrinated to raise money *before anything else*, that they become confused as to why they're even there.

The Seminal Question: Why Am I Here?

After 30 years in the business, I can categorically say that a whole boatload of board members have little idea about what their responsibilities are. And, to make matters worse, many suffer from imposter syndrome. This lack of clarity and sense of not knowing what to do ends up being a foil for bellicose board members who use the board for self-aggrandizement. In turn, that causes a "senior" and "junior" board member mentality that ultimately obstructs progress. Board members do seem to know that raising money is important. They also have little faith in their own efforts to do so. Almost all are trying hard to achieve something for the organization, but they're not participating in professional development or board engagement opportunities, leaving that to the leaders among them. Or, in the rare case where a "junior" board member attends a board development forum, it usually concerns a single subject (such as Diversity/Equity/Inclusion) to which the senior board members have no interest in gaining insight. They'll cheer on the "junior" much as a parent would cheer on their child at the school play, but ultimately dismiss the findings as, at best, interesting.

In today's version of normal, nonprofit arts board members have to become acutely aware about why they're there. The nonprofit arts scene has changed dramatically. No longer can a company determine that its produced/presented art is a nonprofit product just by its existence. "Art for art's sake" is not a charitable mission, it's a cop-out. For nonprofit arts organizations, art has to be a means toward an end that will quantifiably solve or mitigate the issues in a community. That's what those involved with charity work of any kind have been charged to do.

A quick comment on "art for art's sake," a simplistic, horrible phrase conveying the idea that, somehow, art is an anthropomorphized patron of itself. "Art for art's sake" was useful as a movement in 18th century France as a group of artists'

2

rejection of the generalized purpose of art as a tool to serve the state or the official religion. In the 21st century, the meaning has been bastardized to convey that the production of art — pretty much *any* art — needs no purpose whatsoever. The art itself is the goal. That idea still might hold true for artists, but it does not hold for a nonprofit arts *organization*. As a charity, a nonprofit arts organization has a responsibility to mitigate the social issues of its community.

Toni Morrison was right when she said in 2008 in *Poets and Writers*:

> *All of that art-for-art's-sake stuff is BS. What are these people talking about? Are you really telling me that Shakespeare and Aeschylus weren't writing about kings? All good art is political! There is none that isn't. And the ones that try hard not to be political are political by saying, "We love the status quo."*

So, the next time you hear "art for art's sake," just think of it as the official motto for the MGM lion (*ars gratia artis*) and nothing more. Look for it the next time you see old Leo, right before the movie starts. Rawr.

I Own Your Company (At Least Partly)

My father, Daniel Harrison, a CPA for 50 years or so, used to ask me about nonprofit systems. He'd never handled a nonprofit corporation in his career, so the questions were based on his own experience.

"Who owns your company?" Dad used to ask.

My glib answer was, "You do."

I then explained, after his famed, Spock-like eyebrow-raise that could melt the snark off of anyone, that the owners of the company are the federal, state, and local communities that approved the company to obtain a 501(c)(3) letter from the Internal Revenue Service (IRS). The owners determine the rules of engagement through the IRS code (which, incidentally, makes no mention of the arts as a tax-exempt activity; arts organizations' tax-exemptions are the result of a few court cases that challenged that).

That said, *nonprofit* arts organizations like yours have been given a gift. To advance beyond the crumbling of the industry, you have one tool that gives you a chance to succeed. But you're going to have to change the prism in which you do work to take advantage of that lifeline. That lifeline? *Your organization is a charity.*

BE A CHARITY AND YOU'LL SUCCEED. BE A COMPANY THAT PRODUCES ART FOR VANITY, VISION, OR, HEAVEN FORFEND, "ART FOR ART'S SAKE," AND YOU'LL FAIL. PROBABLY BY THE END OF THIS SENTENCE.

The job of the board of directors is to represent those aforementioned owners. Your job includes determining why the company exists, raising money, hiring the executive director to lead you, finding others who can share the responsibility (and to replace you when you're done), and becoming a freaking

4

zealot for the company by knowing its successes and spreading the word. *Above everything else, you must work in the context of your community's actual, stated needs.*

In this book, we're going to clarify what your primary board responsibilities are: as a group, as an individual, and as a member of your community. We'll look at the toxic nature of the narcissists among your board, staff, and donor base. And you'll have the tools to understand why your company is there, regardless of the level of clarity that you might have had before picking up this book.

It's hard to sit on a board, in all senses of the word "board." Whether you're talking about a splintery plank of wood or joining a collection of people who don't know what they're expected to do, a lack of clarity about why you're there makes for a bad board experience. Use this book as it was intended and you can alter that experience and make your nonprofit arts organization work to the best of its ability as a nonprofit that happens to use art as a tool to achieve a great community.

Be the charity your community wants, not an arts company supported by the elites for the elites to participate. And if you get some blowback, raise an eyebrow. Discover *why* you're getting blowback.

Call me if you need me.

Discussion Exercises/Worksheets

At the end of each chapter, you'll find some discussion exercises for that chapter. Recommendation: discuss these items one at a time with your board. Use a portion of every official board meeting. It's best to do so when attendance is high and you're not having quorum issues.

That said, if the decision is made among the board members who are present, then that is the decision, regardless of those who chose not to attend.

These are not short conversations. You will need to take your time and be prepared. They will require follow-ups when community members are brought in to establish their needs (not yours).

If any impact reveals your company to be either self-serving, vague, or confusing, continue to dig to the center of the community's needs before your own. That's where the answer is.

Here's where the answer is not: "Because art nurtures the soul" or "Isn't art enough?" Neither of those thoughts help you make your community members healthier, smarter, clothed, housed, or less hungry, for example.

And that's what nonprofits are constructed to do. Even nonprofit arts organizations. Today, in what I like to call the "Pre-Post-Pandemic Era," that holds true *especially* for nonprofit arts organizations.

Your goal is specificity. Bring something precise and quantifiable to the table. Don't lean on art as the end product. While art may be essential, your arts organization is not, nor is your version of art. The art you produce must be a tool to achieve positive (and measurable) impact.

Foreword

I love the performing arts. Ever since I was a child (thanks to my German-born artist father and theater-major-turned-elementary-school-teacher mother), they have entertained and educated me, expanded my worldview, and enriched my emotional experience. As an adult, I have had the privilege of attending up to 50 performances per year of dance, music, and theater produced by companies large and small throughout North America, and made good friends with many of the people who make the magic happen. Through them, I learned two fundamental truths: 1) Art makes you think or feel things you would not otherwise have access to — everything else is mere entertainment; and 2) Great art can only be produced by companies with strong leadership from the top down — *i.e.*, a working partnership between the General Director and a fully engaged Board.

Having discovered Alan Harrison's blog during the dark days of the COVID shutdown, I now realize there is a third important tenet: 3) Art should move us not just to think and feel differently, but also *behave* differently — specifically, it should stir us into action to improve the world in which we live. (I refer you to *Scene Change: Why Today's Nonprofit Arts Organizations Have to Stop Producing Art and Start Producing Impact*, if you have not read it already.)

As a member of several advisory boards, working subcommittees, and supporting guilds for variously sized opera companies over the past 15 years, I understand "producing impact" is a radically mind-bending and enormous challenge for most organizations. Even when the artists themselves are committed to that cause, their voices and efforts often get lost in the shuffle because company leadership is more (and somewhat

understandably) concerned with the literal bottom line: butts in the seats and the money pulled from the wallets they sit on.

Oddly, it seems many directors these days are putting more emphasis on form over function (hiring expensive consultants to "rebrand" the company) and style over substance (redesigning the website with fancy graphics) than producing art to meet specific needs within their communities. And sadly, I have seen way too many boards made up of well-meaning patrons who are "passionate about the art form" but more interested in being members of an elite social clique and planning the next gala party than doing the hard work of true development (establishing relationships and deepening engagement with others) for their chosen company.

Clearly if the performing arts are to survive — and hopefully thrive — in our 21st century society, they need a radical new strategy. In his first book, Alan outlined *why* most organizations are misguided and *what* they need to do differently. In this volume, he poses more thought-provoking questions and exercises to help company leadership flesh out *how* they can accomplish this daunting task.

Alan's blog [501c3.guru] and books have dramatically reshaped my lifelong relationship with the performing arts. I know Alan's views regarding what nonprofit arts organizations are mandated to do are controversial and provocative — but isn't that what art is supposed to be?!?

Heidi Munzinger
Performing Arts ~~Advocate~~ Zealot

Change is inevitable — embrace the change.

Acknowledgements

Along with the people mentioned in the book, as well as the people mentioned in the last book, I'd like to acknowledge the encouragement, inspiration, and wisdom I have gained from the following:
Danny Harrison, my brave and brilliant son
Donna Oslin, my brilliant and brave partner in crime

Christopher Barton
Stephanie Beaudoin
Ross Coapstick
Kel Dylla
Nell Edgington
Ariel Fristoe
Chrysoula Hatzilias
Lisa Hayes
Paul Heppner
Jeff Herrmann
Katrin Hilbe
Kelly Hudson
Kate Larson
Steven Libman
Dianne Loeb
Lynn Manley
Vanzetta Penn McPherson
Frank Parkes
Jay Pennie
Martin Prelle-Tworek
Liz Pruyn
Dean Pulliam
Charlie Rathbun
Kimberly Sewright Reich

Cynthia Setel
Furrah Syed
Jodi Walder
Mark Walmsley
Jerry Yoshitomi
Liza Yntema
And hundreds more who have fallen out of what's left of my memory. Bless you all.

Michelle Auerbach (Editor) is in the business of saving lives and increasing bravery. When things fall apart, Michelle is the world builder and a community maker who uses all her geeky skills to transform what we've got to work with into a more just and loving place where more people get taken care of better. She holds an MFA in prose writing from Naropa University and is completing her PhD in Transformational Leadership, with her dissertation on story as a technology for trauma-aware change for individuals, organizations, and communities.

Introduction

Alabama, Mon Amour

During my years at the Alabama Shakespeare Festival (ASF), in a state not known for its tolerance on racial issues, there were 88 members of the board. In case there's a smudge in your book, that number was eighty-eight.

It was the largest nonprofit theater between Atlanta and Houston (east to west), and Louisville and Florida (north to south). On top of that, ASF is in Montgomery, the state capital.

ASF was a year-round theater company called a Shakespeare Festival that also had an artistic mission to tell the stories of the South. There were lots of plays about the experience of Black people. They practiced color-blind casting (a terrible phrase because it implies that the performers were only hired because they were not White). This was not a popular feature of the company as it baited the inherent prejudice held by many people in the state, including board members.

ASF was placed in Montgomery by Winton "Red" Blount, the billionaire contractor and former postmaster general of the United States under Richard Nixon. He donated his own land — 44 acres — and paid for the building, about $22 million in 1985 dollars. Like many southern buildings of note, the outside and the public areas were exceedingly fancy while the offices, rehearsal spaces, and shops inside were utilitarian, to say the least, with their dentist office drop-ceilings and ratty carpeting. And there weren't nearly enough offices and rehearsal rooms for an institution that large. Maybe they've fixed it up by now, but by the end of my time there, we were using old Montgomery School District portables (e.g., decrepit trailers) to rehearse, teach classes, and have meetings. They were in the back, of course, hidden from public view.

ASF had its glory days, to be sure, but when I came in, it had run aground, with five consecutive years of six-digit deficits. The accumulated deficit swelled to 1.6 million dollars.

There was an endowment fund, which was relatively healthy for its age, but the campaign that accompanied it labeled it as a "forever" fund. In doing so, promises were made to donors that their contribution would never be used as anything except a core balance; and only the interest from that core would spin off into ASF.

Sadly (and this happens all too often) the endowment dollars were raised to the detriment of the annual fund (money had been donated here instead of there, not here and there). The endowment hit its initial goals, while the organization, facing unwieldy deficits, laid off people, froze spending, canceled productions, and otherwise cut, cut, cut. That was the environment on my first day.

Some of ASF's board members were only there because Red (who died in 2002, my second year there) virtually hammerlocked them into giving. And, as the leader of the organization (and the

leader of the Alabama Republican Party), he promised anyone who gave at a certain level that they would be board members.

Hence, 88 board members. In three years there, I only met 56 of them (yes, I kept count). The rest weren't interested in taking a call, let alone a visit.

Those details buttress a difficult story. In it, no one comes off well. Certainly not me.

Steak, Sweat, and Politics, Y'all

I was having dinner with a board member in Birmingham, which is the population center of the state, 90 miles from Montgomery. Montgomery, like many state capitals, is not very big. It's just that a lot of famous/notorious things happened there.

We were at a pretty fancy steakhouse, just the two of us. The menu was huge, with just about every cut of a cow available for purchase. This was a dinner designed to ask this board member for his annual gift. Previously, he had given about $100,000 in unrestricted, annual money, to be renewed each year.

My task? To get that renewed gift.

We were talking about all the initiatives that had happened in the previous year. And, as I didn't really know him well because I'd only been on the job less than a year, my only relationship with him was through the theater's activities. But he was always jovial and seemed more intellectually curious than most of his fellow board members, and we had had a few nice social chats.

I had told him, as has always been my wont, that this was the dinner at which I would make this year's ask. I can't tell you how much pressure that takes off the meeting, for both the executive director and for the donor. They know why they're there; it's not a game. It makes the conversation more intimate, more revealing, and far less formal.

When the steaks arrived, the opportunity availed itself. I asked.

After all these years, I can tell you without qualification, these were his exact words in response:

"Now, Alan," he drawled, suddenly sounding similar to Foghorn Leghorn from the old Warner Brothers cartoons. "Can you tell me something?" said the board member.

Without my response, he continued.

"Now, why do you do all these plays for the N*****s?"*

He paused, letting that question sink in.

"I mean, they don't come. They're unsophisticated. They're uneducated. They don't like us. And whenever y'all do a play with them in it, it's like you're rubbing our nose in it."

[*Note. He did not say the word you might think he said. It's a derivative of that word, however, and equally appalling. Just swap "er" with "ra" and that's the word.]

That comment changed my job. Now my job was to renew the gift of, and cater to, a racist.

I was born in Los Angeles. I used to kid people at ASF that I had been born in a city further south than Montgomery. But I had never lived anywhere in the Deep South before this job, and did not want to ruffle too many feathers in year one. I didn't know where the landmines were and I really didn't want to step on one so soon.

I didn't know what to say. The board member sensed this unease.

My father, that aforementioned well-known mensch and stand-up guy, had once given me some advice. Because he had just died a year earlier, he had been on my mind as I waddled through this minefield.

He had told me years earlier that if things ever get difficult, get up and go to the bathroom. It'll buy you five to ten minutes. It's a brilliant piece of advice and I've used it more than once. This was my first time trying it out.

While in the bathroom, I got into a stall, locked the door behind me, and thought. After the initial shock and a strong

wave of anger at a whole slew of people, including my development director, my artistic director, and anyone else who came to mind, one phrase that kept occurring to me was this: "It's not your money."

I said it out loud, like a beginning actor learning a line, stressing a different word each time I said it.

"*It's* not your money. It's *not* your money. It's not *your* money. It's not your *money*."

I did not write the bylaws of the Alabama Shakespeare Festival. I obviously did not write the plays, either. I wasn't there at the founding of the company, nor had knowledge of anything resembling its public standing or why its community had supported it. It was neither my job nor my right to slam a board member for his politics, especially when his politics were likely representative of the community in which the company did its business. I did not dictate the company's varied policies.

That doesn't mean I didn't want to punch the guy or walk out. Honestly, those were the first two impulses I had. But had I done either fight or flight, it would have been a dereliction of duty (and a ticket out of a job). His racism, I ultimately reasoned, was not my immediate problem.

Which is greater? One's fiduciary responsibility to one's nonprofit organization? Or one's personal, deep-seated value system? What happens when one clashes with the other? How far over the line of decency are you willing to go to get a donation for your nonprofit arts organization … and why?

I remembered my job, hateful as it had become in the moment. I wondered if this was going to occur again and again. I was sure that it would. I would have to have a good-enough answer. And we really needed the money — as I mentioned, the place was in deep debt.

So, nervously and with some unpleasantly chilly perspiration oozing down my neck, I headed back to the table. He was still there, patiently waiting for an answer.

At that moment, I thought about the fact that there were 87 other board members. Not one of them accompanied me on this particular call. I was feeling a bit put out by that.

Emotions were running high inside me. But, as a halfway decent poker player, I went all in.

"You bring up an interesting point," I said. "It's a point that I will bring back with me tomorrow when I attend the artistic department meeting. I think the whole team should think about where we stand within our community. And then I'll be sure to give you a call and let you know what they've said. In the meantime, can I count on you for $120,000? [a 20% increase]."

And then I stared at him, waiting for my answer.

"Yes," he relented. "That should be fine."

We (I) immediately changed the subject to college football.

Was it the wrong thing to do? What would you have done?

As for me, I felt dirty and disgusted with just about all of my life choices to that point. This wasn't winning a $120,000 poker hand by bluffing; it was by compromising my core values.

I felt like showering all the way home, a 90-minute slog. When I got home, I stood in the shower for well over a half hour, until the water ran ice cold. And I used up most of an entire bar of soap trying to wash the sludge out of my soul. I never did.

Yes, I did my job and ultimately, given the donation, did it well.

But this unexpected part of the pig in the sausage-making of raising money certainly didn't make me feel proud of a "job well done." I wish that it had been the only time a board member cornered me to give me their views on Black people. It was one of several.

To live a full life, I believe that you should live in a foreign place for no less than three years; a place where the locals do not speak your language. After my time in Alabama, I can honestly say that I have lived a full life.

Toxicity Is Not Always So Obvious. Consider Your Own Board. Consider You.

Everything that has led you to be who you are at this moment informs your opinions and your reaction. There were also some wonderful people in Alabama, because there are some wonderful people everywhere. Similarly, there are some horrible people in Seattle, where I now happily live, because there are some horrible people everywhere.

Have you generalized your opinion of some people because of their zip code?

What I consider toxic may not be what *you* consider toxic. More importantly, toxic people generally do not think of themselves as toxic, nor is toxicity the proprium of bad people. Life is not so black and white, which is that fly in the ointment of the supposedly pure "cancel culture."

The key weapon gained by toxic behavior is power. The second-most harmful attribute of narcissistic leadership is the unleashing of power for the sake of a single self. The act of kowtowing to unreasonable demands provides sufficient proof of excellence to narcissists, continually feeding their unquenchable addiction to power. But narcissism is narcissism, a state of being that requires the bearer never to believe that he or she is acting anything but authentic. Just like other toxicities, narcissists don't believe they're narcissists, nor is narcissism the proprium of bad people.

The *most* harmful attribute of narcissism exists on the *other side* of the relationship. When a company whose goals are charitable is forced by policy, politics, or ham-handed, stereotypically capitalist behaviors to choose to satisfy the narcissists over the underserved, that's when wrongheaded decisions get baked into its community-based mission.

Unfortunately, that's where we are today in the nonprofit arts sector. It is still the only portion of the nonprofit sector in which the donor is also the beneficiary. Donors donate so that

donors may attend. And that elitist way of thinking has led to a Birmingham steakhouse menu full of destructive issues ... with no bathrooms in which to escape.

This Alabama story, along with the foregoing chapters and discussion materials, have been designed for you to create a board of directors that services your community. You will be working alongside people with different backgrounds (if your board is composed correctly) who bring their own life experiences to the table. You will not agree on everything. Hell, you might not agree on a lot of things.

And despite changing the way in which you do business to give the company its best chance of making your community a better place, there is still a chance that you might fail, at least this time. All you can do is take a look at your people and make sure that your board members are giving the organization its best opportunity to succeed. Before you do that, however, you have to decide that your arts organization's tangible, quantifiable impact is all that matters.

And, in the case of that Alabama board member, you have to decide who you want to benefit from that impact. Who *do* you want to benefit?

Discussion Exercises/Alabama, Mon Amour
Reread the introduction. Consider the time (summer 2001), the place (Alabama), and the people involved.

1. Considering everything, what would you have done differently had you been in Alan's place? At the table, in the bathroom, in the car ride home, at the meeting the next day, etc.
2. Which is greater? One's fiduciary responsibility to one's nonprofit organization? Or one's personal, deep-seated value system? What happens when one clashes with the

other? How far over the line of decency are you willing to go to get a donation for your nonprofit arts organization … and why?

3. What would you have done differently had you been in Foghorn Leghorn's place?

4. In that organization, which issues might work for your organization?

5. Which issues would not?

6. Was the board more powerful because it had 88 members? Less powerful? Why?

Is Your Board Broken?
(How Would You Know?)

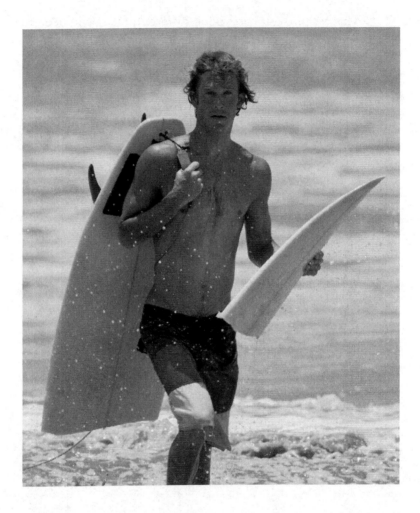

It's the first Tuesday in February. Welcome to your first board meeting!

It's 7:00pm. You rushed home, had a quick dinner, and drove like a bat out of hell to get there at 6:55.

You're among the first people there.

You were unanimously elected to the board at the January meeting. Two weeks ago, you had a ten-minute orientation led by another board member, the person who cajoled you to serve. She showed you the board contract. The board contract starts with a stipulation that it is the responsibility of the board to raise money for the organization.

Board membership requires: one of the top three gifts you donate each year; a purchase of (or sale of all the tickets to) your own personal table at the annual fundraising dinner; at least two sets of season tickets to the company; service on a committee; and a commitment to proselytizing for the company at every opportunity. You've toured the venue, met an artist or two, and had a cup of coffee with the executive director and artistic director, both of whom thanked you for serving.

You didn't quite realize before the board election exactly how much membership would cost. You can afford it. Or maybe you can't. But now the contract is signed. Either way, it certainly would have been nice to know before the January meeting.

Somebody pours you a glass of wine. You later discover that this was the development director. You get a queasy feeling each time she looks at you, as though you were prey.

The chair calls the board to order at 7:15. The last person walks in the room. Conversational hubbub begins anew and more minutes pass.

At 7:30, the chair actually pounds the table with a real gavel. I guess you can get anything on Amazon, but you wonder: is this a play or a meeting?

The chair reads the agenda. An intern sits in the corner taking minutes. Robert's Rules of Order directs the stilted conversation. The chair takes twenty minutes to issue an opening statement. He talks about how lucky the company is to have its artistic staff. The executive director smiles nervously, never having been mentioned.

There are myriad motions, seconds, and endless discussion on even the most mundane things, every now and then punctuated by a unanimous vote. If the vote is always going to be unanimous, you ask yourself, then why does it require all this discussion? Do people here not know how to take "yes" for an answer?

Just as you reach for the bottle, the omnipresent development director pours your second glass of wine.

It is now 9:00. You worked all day, and now you're having trouble keeping your eyes open. Suddenly, the board chair looks at you and asks you to introduce yourself. You stand and clumsily tell people who you are, why you're there, and how excited you are to get started. You look around and see multiple glasses of wine being poured and quickly receive a tidy, overstuffed binder from that cobra-eyed development director. She explains nothing.

You sit, and at 9:05, the artistic director waxes poetic about the next production for about a half hour. He talks about the performers, the design — he even brings a tiny mockup of the set — and his vision. He announces that the event will be completely sold out. The marketing director winces.

(You later discover that the artistic director always says the events will sell out.)

At 9:30, the head of the development committee begins her report. You notice that she is sitting almost on the lap of the development director who smiles broadly, teeth bared, like a ventriloquist. The committee head, whose facial expression never quite changes, tells the fabulous story of all the work done by the development leader and all the fundraising programs that have been launched.

All the discussion leads to an impression that, if there are financial issues for the company, they don't seem to be emanating from the development department. At least that's

what the head of the committee keeps saying. You wonder as you listen: did the development director's lips move?

The meeting goes until 10:30. Nothing is discussed except how the company is doing against the budget for the year, and even that is couched with caveats. The executive director's report begins. She announces, just as she had written in the report that preceded the meeting by two weeks, that the company is short on payroll, due that Friday. Most of the board members are surprised by this information. You'd read the report when you received it, so you already knew. Didn't anyone else?

The board chair says, glumly, that tickets must be sold, money must be raised, and expenses must be cut. The rest of the board members nod. One board member wants others to start an endowment fund. Another recommends that Warren Buffett be notified. Still another, an heiress, writes a check, right there at the table, to cover the payroll for that week. She receives applause.

The board chair suddenly adjourns the meeting and requests an executive session. The motion is seconded and discussion ensues, where not much is said. Staff members are excused. The chair advises the rest of the board that unless the executive director raises more money, there might have to be a change in leadership.

"Isn't that our job, to use our connections to raise money?" you ask.

"I don't have time to raise money," replies the board chair, sternly. "That's what the executive director is supposed to do." The rest of the board nods in agreement.

You ask innocently, "Then why is it in the board contract?"

The meeting is adjourned at 11:00. As you watch people file out, you make a note that there was no report about the needs of the community. Is this the right board for you?

Is it?

Boards. Can't Live With Them.
Can't Live Without Them.

Given the COVID-19 pandemic of the early 2020s and the fact that you're reading this right now, you've likely made it through some few pretty significant years. Congratulations might be in order; however, "making it through" is not a terribly high bar.

Presumably, given the subject matter of the book, you are intimately involved with a nonprofit arts organization somewhere in the world. Maybe you're a board member. Maybe you're an executive director, a managing director, an artistic director, a development director, or a marketing director. Certainly, your workplace has appreciably changed since 2019.

On the other hand, if your workplace has *not* appreciably changed since 2019, you should see that as a red flag. After a global, unending pandemic, social justice awareness, and all those talented people who left their jobs during The Great Resignation, every company around you has changed the way it does business. If the reason is some sort of artistic heel-digging — being proud of an unchanging environment — then one of two terrible things is happening. Either your company and your board have blithely chosen to soldier on, believing that the art you produce or present is neither more nor less relevant to the times in which we live; or you simply haven't noticed that the company has changed the way it sees the world. Neither intransigence nor intentional blindness are laudable traits. Indeed, both are signs of hubris, the worst of all the tragic flaws.

Perhaps the highest need for systemic change falls on the nonprofit arts sector, where despite claiming creativity, culture, and imagination, too many organizations utilize an almost mechanically anti-charitable model.

And it's been this way for too many years.

Hierarchical structures; elitist donors who donate so that elitist donors benefit; Eurocentric programming ("celebrating

diversity" is a phrase used by White people and tokenizes the effort); an artistic director's untethered vision piloting the company's purpose (rather than an actual charitable mission to help people); and continuing to spend thousands of staff hours and billions of dollars building buildings to create a fallacious, phallic façade called "legacy" — these, and more, are pulverizing viability issues that haunt the arts.

Sadly, most nonprofit arts executive directors, development directors, and board chairs have responded with a petrified, desperate plea. "We know we put out a press release about equity, but forget all that stuff for now. We just need to raise more money! Now!" Rather than changing the flat tires of the company, they obstinately beg for more gas.

Tabula Rasa. Time to Start from Scratch.

Take this bizarre moment in history to toss away all previous discussions about your company. Those debates may never have been relevant to society. Now, however, you can do something about it. Things have changed. There are few precedents to copy.

Few, but not none.

In 1962, President John F. Kennedy laid out his "tabula rasa" case for space. Here is the final part of the speech:

> *We choose to go to the moon in this decade and do the other things, not because they are easy, but because they are hard, because that goal will serve to organize and measure the best of our energies and skills, because that challenge is one that we are willing to accept, one we are unwilling to postpone, and one which we intend to win.*

Substitute the phrase "go to the moon in this decade and do the other things" with the activities you undertake after you

decide why, how, and what tools you'll need to undertake them. Nonprofit may be a term of law, but it has a sacred responsibility nonetheless.

Each state in the US has its own rules and regulations regarding what it takes to start a nonprofit. Think of these not as punitive or intrusive, but as helpful boundaries. Boundaries remind us that your nonprofit cannot be all things to all people, everywhere, at all times. "We are all things to all people, everywhere, at all times" would be the lousiest of all mission statements.

More is not better. Focus and impact are what count. When boundaries force you to focus on the problem (rather than focusing on all the things you bring to the table), issues get solved.

To start fresh, treat your company as though it were new. Not one that is "re-opening," but one that is "opening." Think of your company as one that has never existed before now.

Think: why are we starting a nonprofit? Is there a problem in our community that a nonprofit organization can solve better (or more creatively) than a commercial one? And what is it about the arts that serves as a tool to solve that particular problem?

Think of it as a startup, with no reputation or history. And no baggage.

Contact your secretary of state's office to get a full description of the responsibilities of a nonprofit's directors, just as though you were starting a new nonprofit arts organization. It's probably on their website. Generally, the rules are similar state-to-state, but it's good to check for any idiosyncrasies attached to your particular state's laws (or the laws of the government entity that provides nonprofit designation in your country).

In the 2020s, the structure and responsibilities of your board should be different than what might have been expected in the 1970s. If you're a company with some history, this is the time

to get out the corporate Drano and start fresh. Regardless of whether your organization is old, big, or well-attended, it does not mean it deserves its charitable standing in your community. Venerability has nothing to do with impact. Nor does the size of your audience or budget. Pardon the expression, but *size doesn't matter.*

Rather than looking at your organization as it is now and changing it (for these purposes, anyway), try to build it from zero. One that fits the time we're in, instead of the time we once were in. The result of your work will undoubtedly be a change from the organizational structure, purpose, and impact you have now. Change is good because time keeps moving, whether you like it or not.

Time adds a variable to all your actions as a company. Time causes aging, maturing, decaying, and evolving, all of which constantly causes shifts in strategy. If your organization does not "change with the times," as the saying goes, it can become fossilized. When your organization chooses to do the same thing now as it did 50 years ago, you cannot claim your organization has achieved much in the way of progress, can you?

A Zero-Based Nonprofit Arts Organization Must Have a Purpose Befitting the Time in Which It Does Business.

"Tabula rasa" forces you to examine — not "re-examine" — the issues your nonprofit can attack. Like a zero-based budget (a budget not based on layered, year-after-year projections, but on determining revenue and expense from scratch), a zero-based nonprofit arts organization evaluates its purpose from an unfixed point of nonexistence. When you base your nonprofit from a fixed beginning point, it handicaps your ability to account for the variable of change.

At zero, you simply take the issues that are most important to your community and build an organization best equipped to

solve or mitigate those issues. It is tempting, however, to view it as changing the way you do business. If you insist on thinking this way, be aware that purpose is more important than simple change for the purpose of change.

Changing from a suit and tie to a formal evening gown is unproductive when the object is to go swimming. That's an example of change for the sake of change.

In fact, change for the purpose of change can be damaging. At best, it is akin to repositioning the deck chairs on the *Titanic*. The motivation may be there to improve your impact, but if the focus is simply on change without direction, you won't likely be able to get stakeholders on board. If they have to make the difficult move to change the manner in which they work, they're going to want to know why and to what end.

Change for the purpose of purpose energizes your stakeholders. It might, however, distract *you* if you continue to insist that, in a nonprofit environment, the art you produce is the end product. It's not.

This Book Might Be the Best Book in the History of Books. But Read Everything You Can Anyway.

There are some wonderful board development books out there. Read several. Study their morals, but not their examples, because it might make you fall into the trap of just copying another nonprofit's board. That nonprofit might be middling. Do you want yours to be middling, too?

Knowing why its systems work is more important than knowing and replicating its systems.

You may not think that your board needs to be revised or rebuilt. It does. If nothing else, you need to find out regularly *if* it does. Obviously, if your organization is older than the pandemic, then it was formed under unambiguously different circumstances. Millions of COVID cases in the US. Millions

of deaths worldwide. The Great Resignation in full throttle. The crescendo toward gender pay equity has both stalled and become louder. To the world around you, DEI is not just a set of initials, nor is a statement or manifesto valid anymore — especially if the reason for inaction is potential increased cost or revenue loss. The arts have suffered the largest decrease in revenues among all segments of the nonprofit sector.

Things around you have changed. If you have not — worse, if you believe you need not — then *your company has become the problem, not the solution,* no matter how pretty your art may be.

As you've thought about the questions from the previous section, you might have tried them out on your stakeholders. A good idea. Be prepared to have and hear unpopular responses. Popularity is the least valuable reason for making decisions, but unpopularity can be emotionally wearing just the same. Just because an idea is unpopular doesn't make it wrong. It might be that the unpopular ideas are ahead of where everyone's mind is at the moment in which they are presented. After all, American women getting the right to vote was unpopular — until it wasn't.

Plus—and this is a crucial characteristic of brainstorming — ideas are not something to be sifted, stifled, or censored before being presented. Always, both for yourself and for all the stakeholders of your company, go for quantity over quality. The more ideas you have about what your "new" organization might do, and why it will do it, the more colors appear on your palette of activities and purpose.

It's not that there are no bad ideas. There are *a lot* of bad ideas. But you need to hear them out loud before you dismiss them; some of them may merge with other thoughts to become inspired ideas that lead to quantifiable impact for your charitable organization.

If You Can't Measure It, It Doesn't Exist: Quantifiable Impact

The idea of quantifiable impact may be new for your company's artists, at least in terms of the kind of impact that is designed to provide a better life for those in your community who have few advantages in life. But that's the purpose of a nonprofit, isn't it? Unlike the commercial version of art, the nonprofit version uses art as an instrument to solve a societal need. It's disappointing that we continue to hear from poorly run or obsolete foundation personnel who harp about irrelevant metrics such as audience totals, financial stability, national data, and the preoccupation with "mitigating risk."

To wit, using a food bank as an example:

ABC Food Bank with a million-dollar expense budget provided food for 500,000 random individuals one year. The users came to ABC to get the food. The company showed a $100,000 surplus, caused in part by a $100,000 grant from a foundation impressed with their quantity.

ABC wanted to deepen its impact. The following year, the same food bank used a million-dollar expense budget and provided twice as much food apiece to 25,000 individuals who were selected because they were empirically considered the poorest, chronically hungriest individuals in the community. ABC delivered the food to the users. They even prepared the food from their delivery/food truck. They ran a $100,000 deficit because that same foundation correlated serving fewer people with lesser impact and held back its support.

That foundation's ineptitude is an example of foundational ineptitude: blind to the work, unaware of its own metrics problems, and unable to make the right conclusions based on positive results.

Everyone seems to know this is idiotic (and normal) funder behavior, yet this line of illogic springs from foundation

and corporate funding for the arts all the time. Just because foundations have money does not make them ideal funding partners. Want to hear why Donor Advised Funds are dangerous?

A Quick Word About the Elitist Nature of Donor Advised Funds

There are myriad books that dissect the problems with most Donor Advised Funds, which currently are estimated to comprise hundreds of millions of dollars.

Will Hobson wrote in the *Washington Post* in 2020: "Known in the industry as DAFs (rhymes with calves) — and criticized by some insiders as 'zombie philanthropy' — the money and assets in donor-advised funds are intended to go to charity someday, but there are no payout requirements, and money can sit in a donor-advised fund for decades."

What's in it for the donor? The donor gets a tax deduction, earns interest on the money sitting in the account, and gets the acclaim for having made a substantial donation to charity, which has a good deal of ethical worth in society.

However, the donation doesn't help any nonprofit. Including yours.

The value of that DAF is naturally reduced year over year because money becomes less valuable with time, not more. Look up "time value of money" — there you'll find equations and calculators to prove how money devalues with time. $100 today buys more than $100 ten years from now. Time-depleted dollars mean lesser impact for whichever nonprofit finally gets the donation, even though the donor has reaped all the benefits of a higher value. And in times of stress — the COVID crisis years, for example — there is no incentive to use the money where it could do immediate, emergency-caused good.

Donor Advised Funds ought to be required to be fully depleted by no later than the third anniversary of the designation, rather

than the current law, which is *forever*. Otherwise, it's useless to the community, regardless of the boon to investment companies that provide them.

Some people like Donor Advised Funds. Among them are well-meaning people — along with a plethora of tax cheats and miscreants.

Don't Fall in Love with an Archetype

Impact is more important than excellence. Your board needs not only to understand that, but live it, breathe it, and shout it from the hilltops. So, what format works for that kind of zealotry? Is it a traditional for-profit corporate board design (whatever "traditional" means)?

As a discombobulated writer once wrote, "Don't fall in love with an archetype."

You have to decide how best to put together your board of directors. Not what every other company is doing. *You.*

In designing the perfect board, use a pencil with an eraser, because as the project develops, you may find opportunities to get better, deeper impact (not *other* impact — *deeper* impact).

What does impact look like for an arts organization; more specifically, your arts organization?

That's the big question, to which there is no pat answer. The answer is germane only to your community. Your community has particular issues. They may seem similar to some issues from other communities. But only your community has your community's issues right now. The purpose of a nonprofit — even a nonprofit arts organization — is to mitigate or eliminate those issues.

Living Proof, Example One

"In a world meant to celebrate creativity and innovation," said Judith Bowtell, CEO of Sydney, Australia's Milk Crate Theatre (MCT), "it seems amazing that we even need to have the

discussion about encouraging these qualities in performing arts and theater companies."

What does MCT do that other, "traditional" theater companies do not? Here is their stated mission, vision, and the description of their community challenge as a nonprofit organization.

Milk Crate Theatre effects social change through the power of performance.

Milk Crate Theatre provides opportunities for people whose voices are under-represented to engage in artistic practice to build confidence, skills, and connections; and shares bold and resonant stories to build empathy and break down barriers.

Milk Crate Theatre's community of Collaborative Artists are people whose voices are under-represented. They are generally living with, have experienced or are at risk of homelessness; living with mental health or disability support needs; have experienced domestic violence or come from culturally and linguistically diverse communities. We work with arts, social purpose, government, and corporate and funding partners who can increase our participant and audience reach and impact.

MCT's productions are acclaimed, but its impact does not rely on artistic excellence alone. Rather, it has been using the performing arts to change the usual trajectory of homelessness. In the last four years, MCT has empowered 78% of the company's participants to experience measurable, positive changes to their lives.

I asked Bowtell to tell me what innovation in the arts means to her. These were some of her replies, starting with what innovation is *not* and ending with what innovation *is*:

Innovation in the arts is not about being self-serving to those in power and privilege to keep your infrastructure and bottom-line comfortable. Innovation is not programming a work written by an

Indigenous writer and getting a White person to direct. Neither is commissioning work by "emerging" women in a program that has always been developed by a man. Innovation is not about programming to keep your existing audiences. Innovation is not the core business of "infrastructure" and "heritage" companies that need to keep the engine of work turning over to provide employment for 10,000 workers.

Innovation is in the small labs and spaces, in the artists reinventing themselves to use their skills in commercial and social enterprises. Innovation is providing leadership opportunities to diverse people, who reflect those that live, work, and play in your community. Innovation is constantly questioning what you are doing — evaluating, monitoring, researching your impact. And then having the bravery to step outside the box of ego and make change.

"I was literally hit over the head the other day about how the 'elite' arts experiences in Australia are for a very privileged class," Bowtell added. "After listening to well-heeled baby-boomers talk about how convenient it is to get the ferry from their multi-million harborside homes to the Sydney Opera House, I was whacked over the head by an older woman for daring to send a text before the concert started. Just think about this. This woman felt so empowered as a subscriber to an elite arts company that she felt free to hit another woman in a public space. For sending a text. Before the concert started."

Change is not something inevitable. It is something to be sought. "To quote *Macbeth*, you need to be 'bloody, bold, and resolute' to lead a revolution," Bowtell said.

What "bloody, bold, and resolute" things do you want to do to help *your* community?

The fun and terrifying answer to that question is this:

"We want to do exactly what we feel is necessary to achieve our intended impact. And nothing else."

Discussion Exercises/Is Your Board Broken?

As you think about your 501(c)(3) arts organization, what gets you up in the morning? Is the execution of your art more important than the community issues for which it has a potential to solve or mitigate?

Briefly, what are the 5 most urgent issues with which your community is dealing right now?

1.
2.
3.
4.
5.

Which one or two issues stand out among those 5?

1.
2.

Who decided that these issues were the most urgent, you or the community? If you did, choose from among these, and be totally honest:

- The company decided what the issues were.
- Members of the community decided what the issues were.
- We made educated guesses as to what the issues were.
- We either did extensive research or used already-written research to determine the issues.
- We're not really interested in the issues of the community because that's not what we do.
- Other responses

If the community did, how can you help them achieve their goals?

Why are these community issues more important than others? Are there others?

What is it that your organization does that uniquely fills the need of the community?

What makes your organization more effective and deserving than other nonprofits?

What is the art you plan to produce? Why?

Do you have data to support that choice? Or is it just a gut feeling?

Is your programming more inclusive? How so?

Do you do work that tells the stories of all kinds of people in your community, especially those whose stories never seem to get told?

Is your staff diverse in age, race, ethnicity, gender, and background?

What steps do you take to serve people who would otherwise be un-served or underserved?

What issues could you face in standing up for the rights of your underserved populations? Would there be (or is there already) backlash? Are those backlash people toxic to your cause? Are there those who might celebrate your cause if they were involved in its deepest planning?

Do you charge for tickets? Why? Are you just copying what the for-profit version of your art production/exhibition does to pay back its investors? As a 501(c)(3), your responsibility is to your community — is there something standing in the way of presenting your art free of charge directly to the portions of that community that benefit by its production? How do you measure that benefit?

What tools will you need?

Financial support...

- Board members
- Local foundations
- Local individual donors
- Government grants
- National foundations, if applicable
- Others

Do you require a building to be the company's "home"? Why? No, really... why?

Does the energy and cost required to maintain that building outweigh taking the art directly to the people?

Are you already doing a capital campaign to build or renovate another building out of which to produce or exhibit? Why? Are you trying to leave a fallacious, phallic façade called "legacy?" What's more important — your legacy or the community's well-being?

Can you sell the building you're in? (If not, it may technically be a financial asset on the balance sheet, but it's a real-world liability on your cash flow and mental anxiety when the plumbing breaks down. Again.)

Other tools required:

- Rehearsal space
- Exhibition space (traveling)
- Professional development/education opportunities to help your staff get more well-versed in the community's issues without having to guess
- Scenery/costumes/other material needs
- Technical needs (networks, communications, etc.)

- Talented, devoted people (staff, volunteers, board members, donors, etc.)
- Chutzpah
- The "bully pulpit" — a system set up to trumpet both your successes and failures. (The louder you emphasize both, the more involved your community will be, and the more slack you'll receive when you need it.)
- What other tools do you need?

For samples of board contracts, just use the search engine of your choice and type in "board contract" or "board agreement." Find the best parts of several templates and go with it. Or, if you'd like, send me an email at alan@501c3.guru and I can book a consultation with you.

The Very Meaning of Productivity

Now that you have discussed the tools you'll need to be the most productive board of directors you can be for the most impactful nonprofit arts organization for your community, it's time to be productive.

The best method of achieving true productivity is to eliminate all that which is unproductive.

Jim Barksdale, formerly the CEO of Netscape, said it more succinctly:

The main thing is to make damn sure that the main thing is the main thing.

If you discover that your company's desired impact is no different from another nonprofit in your community (except, perhaps, in scope), contact that nonprofit's executive director

and find ways to merge to become a single organization that might be more efficient in its effectiveness. Alternately, you might consider closing your doors in order to let the other company succeed. After all, is it more important to your community that an issue gets solved? Or is it more important that your company must be the one to solve it? (Hint: it's the former, not the latter.)

Define your community — you know, the one you wish to serve. Is it geographic? Ethnic? Socioeconomic? Education level? Focus is important here because, as we've discussed, you want to avoid that "all things to all people" issue.

Is there a chance to work with a non-arts nonprofit trying to serve the same community? Who can help with co-programming? If you've chosen, say, access to women's health centers as a community need because of changing laws, can you produce art that allows for health centers to benefit, monetarily or otherwise? Can you do it because it's the right thing to do, and not as a crass marketing ploy?

Don't Make Your In-House Relationships Adversarial

Now that you've identified what you want your board members to do, how best to serve your organization, and have defined the community and how you specifically fill its needs, human nature comes into blazing focus.

Your community cannot afford a power struggle, either internally among the board members, organizationally among board members and staff members, or externally among board members and members of the community.

From Kate Larsen at the Reset Conference in Adelaide, Australia, as reported on *ArtsHub*:

As a consultant, I hear horror stories almost every day. Nightmare boards. Negligent boards. Boards that don't stay in their lane.

Board that overreach, mis- or micro-manage. Boards that aren't as diverse as the communities they represent. Or that simply create more work than the benefits they return.

Boards that fail in their duty of care to the people they employ — that damage good CEOs, can't manage bad ones, or don't support the people those CEOs fail in their turn.

Boards that don't review their own processes or measure their organizations' success. That get glassy-eyed when asked to fundraise, or quickly edge towards hostile when asked to "give, get, or get out." Boards that have simply lost our trust.

Behind closed doors or in board meetings, disagreements and discord are fair game. A good way to emphasize this is by setting rules that apply to your board and yours alone. I posted this in my office:

Reports are easy.
Board meetings are expensive.
Don't waste time with the unchangeable past when you could be talking about the future.

Let's assume that every single person who attends your monthly board meeting averages $100/hour for consulting. (That's everyone, including staff, and the figure is arbitrary for use in this equation. That average may well be higher, depending on who is in the room.)

Let's say that 20 people attend each board meeting and that 8 people tend to miss them because they got sick, had an emergency, or, frankly, don't see the need to attend. Now let's assume that each board meeting lasts 2 hours.

- 20 people × $100/hour × 2 hours = $4,000/hour per meeting.
- 12 meetings per year = $48,000 spent in consulting fees.

- Lost opportunities: −8 people × $100/hour × 2 hours × 12 meetings = −$19,200 lost.

In this scenario, you've budgeted an in-kind expense of $48,000 for consulting in a year (and that's just for the board meetings — not the committee meetings or any other required presence by your board members, such as a scheduled multi-day retreat), of which $19,200 is thrown out the window right away by the people who do not attend. How do you want to spend $48,000 — on the past or on the future?

Harrison's Rules of Order

Here are some key board meeting rules. For the sake of vainglory, let's call them "Harrison's Rules of Order."

Rule 1. Don't waste the money you've budgeted for board meetings by talking about items that you cannot change.

Rule 2. Consensus is not unanimity; votes needn't be unanimous. After the decision is made, however, everyone needs to back it, because *that's* what consensus means.

I don't know where this habit started, but there's no reason in the world to insist on unanimity in a board meeting. When touchy business arises, instead of tabling the discussion (which inevitably happens because your board chair doesn't want to hurt anyone's feelings), talk it through to the end. Then vote. The board's task is to agree *to the decision* even if they don't agree *with the decision*. That's called "consensus" and a good board would insist on it, even with "no" votes in the public record.

To be clear: votes and opinions need not ever be unanimously approved. At the same time, no board meeting is an exercise in democracy. Democracy has no place in a board decision. If you don't know the difference between democracy and consensus,

think of it this way. In a democratic process, there are losers who continue to battle against what they perceive to be an injustice. But, as Winston Churchill said in 1947:

> *Many forms of Government have been tried, and will be tried in this world of sin and woe. No one pretends that democracy is perfect or all-wise. Indeed it has been said that democracy is the worst form of Government — except for all those other forms that have been tried.*

Consensus happens when those who disagreed with the decision before it was made choose to back the decision after the vote because it is in the best interest of the company to show that the board has the community's back. No one ever has the right to say "I told you so" in consensus-driven decision making, because the act of consensus is one of harmony, no matter what, and doing everything possible to back the decision made *even if, individually, a voter disagrees with the majority.*

In a democracy, losers weep. In a consensus-driven organization, losers evaporate as soon as the decision is made and all work their hardest to succeed.

> Rule 3. Never do what the last person in the conversation advocates. It's a trick manipulative people do.

There's a terrific power move that some board members use to get their way. They keep completely quiet during a tough discussion and, at the end, when things seem to be moving away from their point of view as a vote approaches, they'll chime in with their august opinion, as though it were offered from on high. Exhausted people in the room tend to cave when that happens. I suggest you put a stop to the practice. It can only harm your company, and, by extension, your community. All because of one ignominious game-player.

Rule 4. Study the budget before you vote on it (and really, folks: don't begin studying it during the board meeting).

As you and I both know, budgets are tremendously difficult. They take months (if you use your whole staff to produce them) and are arduous. There is pain involved, usually in the head of the executive director and the department heads, but also in the bank accounts of some of the most valuable employees of the organization.

And yet, when they are discussed at a board meeting (after being presented one month earlier so that board members have the chance to study it and ask questions ahead of the meeting), someone inevitably argues about something like "Depreciation" because they don't accept that there are expenses for items already purchased. Or they'll do a ratio test on either development or marketing ("Why are we spending 30% of our revenue on marketing? Why can't we raise money at ten cents on the dollar?"), as though there exist set rules about how much it costs to sell tickets or to raise money. If there's something you don't understand, ask in the weeks before the board meeting, not during. Lots of money is being spent at the board meeting, remember?

Rule 5. No devil's advocates; take responsibility for your disagreement.

This holds true not just for arts organizations, but life. If you personally disagree with something, don't lay it out in such a way that disabuses yourself from the controversy.

"Let me play Devil's Advocate for a moment" should be immediately cut off by the board chair, regardless of the rules of engagement. It could be met with something as simple as, "Terry, are you uncomfortable about something?" Or,

alternately, there could just be a "no Devil's Advocates" rule at every board meeting.

Usually, the phrase, "Let me play Devil's Advocate for a moment," is followed by something relatively outrageous, like "I know that there are some people out there who want to know why we do all those plays for the N*****s." Own up to your own feelings. If you think they're as racist a sentiment as that, you're probably right. And it might be time to leave the board.

> Rule 6. Your executive director is not responsible for writing and executing your strategic plan. You are.

There are too many organizations that leave the strategic plan up to the staff. Not a good strategy. Work *with* the staff to create it, but don't make them write it down or do all the steps necessary for its execution to work. That's an abandonment of responsibility for the board members, and an absolute, unfettered path to failure for both the executive director and the board.

If you need a third party to do the scribing of the strategic plan, pay for it. It is the board's responsibility to collect all information from all parties (board, staff, community leaders, patrons and ticket-buyers, and volunteers) to put it together. It is everyone's responsibility to enact it and to measure all the results.

Every Board Member Has to Give Cash, Too.

When nonprofit consultants and advisors ask your board members to give money to your nonprofit arts organization, it is only because that without 100% of the board donating, the appearance is that the organization does not have 100% support. It's as bad as the one donor that complains. And if the most zealous advocates for the organization don't even donate

a dollar, how can the organization prove that it's worthwhile? (Hint: it can't.)

In case you were wondering why this is a topic, just know that there are those among you who resent having to give actual cash money as a donation when they volunteer all that time. If you believe that, stop it. Give actual cash money. It's part of the deal of being a board member.

How Do Bad Decisions Get Made By an Organization?

You've thought it. You might have shared your thoughts with colleagues.

You've read a press release, an announcement, or a feature article about a nonprofit. You know that there is a tragic error in the content. Not a typo or a dangling participle — the actual content. Somehow, your production of *Hamlet* has been advertised as a wacky comedy (yes, there are funny moments, but no, it's not a comedy). The press release about your performance of Mahler's Third Symphony calls it an easy, toe-in-the-water introduction to symphonic work (it's nearly two hours long). An art history course references Michelangelo as a prolific painter who painted the ceiling of the Sistine Chapel in one hour (he was a sculptor, not usually a painter, and it took him four years to complete the project).

These are content errors that can make it past everyone's eyes into a brochure, a program note, or a press release. They're relatively harmless in the scheme of things, and using some deft crisis management, can be turned around by humanizing the process.

I remember a marketing firm's design of a season ticket brochure, a design that had been approved by everyone (except me — I had just started one day earlier), just about to go to print. On the bottom of every page were the words "Subcribe [sic] Now!"

Stuff happens. And when it does, as long as no one is hurt, "we goofed" goes a long way.

At the Pasadena Playhouse, we always issued three season ticket renewal notices. One year, I wrote the third notice myself, at 2:00am, with a deadline of 6:00pm, when the mail facility closed. I proofread it because no one else was awake to do it (never proofread your own copy). Truthfully, I wasn't very awake myself. The whole page looked blurry to me.

We mail-merged the letters, printed them, and I hand-signed every single copy with real blue ink to about 3,000 households. Then we sent them out to the remaining un-renewed subscribers. We made the post office with ten minutes to spare. The deadline to reply was less than a week away.

The third notice comprised some of the same information from the first two notices, but had a higher urgency attached. If a subscriber did not renew by the deadline, the Playhouse could release their seat locations to new subscribers. Seat location was the major reason, we had found through surveys and other research, for Pasadena Playhouse people to purchase season tickets in the first place. Not the discount, not loyalty, and certainly not "free lost ticket insurance," which was a meaningless benefit.

Location, location, location.

Within three days, the box office received no less than 100 phone calls about the tone of the letter, complaining that it was harsh. That's when the box office manager came to my office, told me about all the phone calls, and asked, "Did you mean to write this?"

"What did I write?" I honestly didn't remember. The whole thing was a blur.

Here's a re-creation:

The Pasadena Playhouse
39 S. El Molino Ave
Pasadena, CA 91101

FINAL NOTICE:
RENEW BY APRIL 1
AND KEEP YOUR
VALUABLE SEAT
LOCATIONS!

Mr. and Mrs. Ima Subscriber
123 Season Ticket Blvd.
Pasadena, CA 91101

Dear Mr. and Mrs. Subscriber,

KISS YOUR SEATS GOODBYE!

Thank you so much for choosing to purchase a subscription to The Pasadena Playhouse. We know you have a lot of options about where to see great theater in the Los Angeles area, and we're proud that you've decided to spend some time with us.

As you know, we cannot hold onto your subscription seat locations forever. But if you renew your season tickets by 5:00pm on April 1st, you'll be locked in to another terrific

Evidently, according to the box office manager, season ticket holders didn't appreciate being commanded to kiss their seats either goodbye, hello, or in any way, shape, or form. I hope a few found it funny, and we put out another letter acknowledging our own doofus qualities. But still, these are the moments when you ask yourself, "How could I have done this?"

They're also the moments when others ask you, "How did this get into the public? Can't you see the obvious problem?"

But at least the letter was an error caused by stupid exhaustion. In Washington, DC, a company made an error that it never understood was egregious in nature. Likely, it still doesn't.

The Shakespeare Theatre Company (STC) produced a musical featuring the work of Britney Spears. That information alone should raise a few eyebrows, shouldn't it?

From Peter Marks of the *Washington Post*:

"Once Upon a One More Time" seems a most unlikely cultural mash-up, reframing Cinderella, Snow White, Sleeping Beauty, and a bevy of other storybook characters in an enlightened, modern

context. Filling out their story is a narrative inspired by Betty Friedan's groundbreaking "The Feminine Mystique," Spears's songbook, the choreography of a pair of hip-hop-savvy directors — and American Idol runner-up Justin Guarini as Prince Charming. If this seems a lot to process, consider, too, that the musical is having its world premiere in Washington at, of all places, Shakespeare Theatre Company, where artistic director Simon Godwin says it's on track to become the top-selling show in the company's 35-year history.

STC's mission, directly from its website at the time of production:

OUR MISSION
Shakespeare Theatre Company creates, preserves, and promotes classic theatre — ambitious, enduring plays with universal themes — for all audiences.
OUR VISION
We create theatre to ignite a dialogue that connects the universality of classic works to our shared human experience in the modern world.

It's a crappy mission, to be sure, because there is no reason in the modern world why this is important. And for all audiences? Even if you assume they mean human beings, does that include babies? Those with severe disabilities? Poor people?

And how does the community benefit? It doesn't say. It only says they "create, preserve, and promote classic theater," not why that could possibly matter to anyone in the DC metropolitan region, let alone "all audiences."

STC's vision is just double-talk. Reread it with that in mind and I promise you'll be properly disgusted that they raise the amount of money they do. And they do it at the expense of other arts organizations who are making a positive, societal difference in the DC community.

But look, times are tough (they're always tough). Money is scarce (it's always scarce). The Nederlander Organization pumped a lot of money into this production as a pre-New York tryout and used STC for their venue and their reputation. It ultimately opened on Broadway on June 22, 2023. It closed on September 3 after only 123 performances, but even if it were a big money-making hit, it still threw a wrench into the trustworthiness of STC.

Cash cows have sunk nonprofit arts organizations into a quagmire of mistrust for years.

If nothing else, every single nonprofit should be the expert at what it does. Not "an" expert. "The" expert. And every time an arts organization such as STC departs from its mission, it announces to the world that it is no longer focusing on its expertise, just its money, or need thereof.

You can't trust them to do Shakespeare if they really want to do "Britney-Speare." This kind of mission-drift results in mistrust in the whole industry, not just at STC. Funders don't like to be fooled into believing that your mission is important when you depart from it entirely for the sake of cash. As such, they'll likely ask *every* potential beneficiary organization to prove that they're serious about their stated mission — no matter what.

At STC, a rapacious desire for "legacy" by the previous artistic director (Michael Kahn, who had reigned for 36 years) led to an unnecessary depletion of resources. As Peter Marks wrote in 2018, before the hiring of Mr. Godwin:

The Shakespeare Theatre Company has had a distinguished run in the nation's capital, winning the Tony Award for best regional theater in 2012. Strong attendance in its longtime downtown home, the 450-seat Lansburgh Theatre on Seventh Street NW, led it, in 2007, to build a 775-seat theater: the $89 million Sidney Harman Hall, on F Street NW, across from Capital One Arena.

It's a handsome space, but its dimensions have proved vexing for many directors — and difficult to fill, both in terms of artistry and audiences. As a longtime theater artist who has worked there multiple times puts it: "The space is too big. It's a black hole."

As my friend, theater expert Eddie Gilbert, once said, "The difference between a 600-seat theater and an 800-seat theater is 200 bad seats."

Surely someone saw this coming. *Someone* in the organization acted like the engineers at Morton Thiokol who desperately wanted to postpone the launch of the space shuttle *Challenger* because the rocket's shielding and O-rings had never been tested in colder temperatures and the outside temperature was a chilly 40 degrees (F) at takeoff that fateful morning.

Unfortunately, someone else in the organization must have acted like the *leaders* of Morton Thiokol, NASA, and the other agencies that dismissed the argument against launching *Challenger* because that would cost too much money and the reputation of the space program. They ordered it to be launched anyway. It blew up.

So we know *how* this crazy decision was made. And we know why: *money*. And that tells us something about those that believe that revenue is more important than impact. Usually, those people reside on a toxic board of directors and its executives.

STC's board and executives displayed the kind of abusive power that puts organizations at risk for irrelevant goals. This is the kind of power that puts people around the decision-making table whose bank accounts led to membership rather than zeal for a mission. It's the kind of power that allows a few argumentative, charismatic characters to make overarching decisions without considering the consequences.

The Pasadena Playhouse subscription renewal letter error was, in comparison, an "oopsy-daisy." STC's error was more of a "*GAH!*"

Discussion Exercises/The Very Meaning of Productivity

Answer the four "Passover" questions below:

Why is this nonprofit arts organization different from all other nonprofits in our community? (Not just arts organizations, which makes it different from the question in the first exercise.)

What exactly is our "community"? (Geographic? Demographic? Etc.)

How is our "community" being assisted right now? (Again, from all kinds of nonprofits and government organizations, not simply other arts organizations.)

Who is our first board member? (Not by name — just describe the person and why that's your choice.)

Calculate the cost of your board of directors.

What is the consulting fee of each board member? $ _____

Get answers from each one, add them together, and then divide by the number of board members. The final result is A.

Next, multiply that number by the number of hours in your board meetings (no fractions, please). _____

Round up for anything more than 15 minutes because the question is about how much time is either allotted or used at the meetings (whichever is higher), not how much time is actually spent at each particular meeting. The final result is B.

Next, multiply that number by the number of board meetings you schedule each year. _____

Include any annual meeting, but do not include retreats, committee meetings, galas, or anything else. Just board meetings alone. The final result is C.

Multiply A × B × C. That is the amount of money spent on your board of directors, just for board meetings, even if some don't always show up (which is money just thrown away).

A × B × C = $ _____ (Z)

Now, make a list of all your committees.

How many are there? _____ (The final result is D.)

How many people are on each committee? _____ (The final result is E.)

How many hours do they meet per year? _____ (The final result is F.)

Multiply A × D × E × F. That is the amount of money spent on just committee meetings. That final result is Y.

A × D × E × F = $ _____ (Y)

Now, make a list of all other hours spent by board members on annual galas, retreats, other events, private meetings with one or more members of staff, phone time, and anything else that falls under the aegis of board membership. Also include the number of hours spent observing the art, either by having bought a ticket, seeing a rehearsal, having a drink with the director, etc.

How many hours were spent on all other activities required by board members? _____ (The final result is G.)

Multiply A × G. That is the amount of money spent on everything else that board members do. The final result of that is X.

A × G = $ _____ (X)

Finally, add X + Y + Z. That is the total cost of your board to your company.
X + Y + Z = $ _____

Now that you know exactly how much your board is worth to your company, it might be worth it to you to include it in your budget with an offsetting "In-Kind" donation in the same amount on the revenue side.

This amount is not inconsequential. Nor is it merely "interesting data." Real time. Real effort. Real energy expended. For all intents and purposes, it is a real cost.

This amount might help you persuade your other board members that when they don't show up, or cause development or marketing departments to chase them down for their donations and subscriptions, or force board chairs to regurgitate already-known data at board meetings because they didn't read or understand the executive director's written report, or spend valuable time gossiping about who's sleeping with whom, it's tantamount to burning money for no good reason.

And every time you burn money, it's keeping valuable resources away from the un-served and underserved people that you're trying to help.

HARRISON'S
RULES OF ORDER

1. Don't waste the money you've budgeted for board meetings by talking about items that you cannot change.

2. Consensus is not unanimity; votes needn't be unanimous. After the decision is made, however, everyone needs to back it, because that's what consensus means.

3. Never do what the last person in the conversation advocates. It's a trick manipulative people do.

4. Study the budget before you vote on it (and really, folks: don't just start reading it at the board meeting).

5. No devil's advocates; take responsibility for your disagreement.

6. Your executive director is not responsible for writing and executing your strategic plan. You are, with all your colleagues.

"… None of Its Earnings May Inure to Any Private Shareholder or Individual."

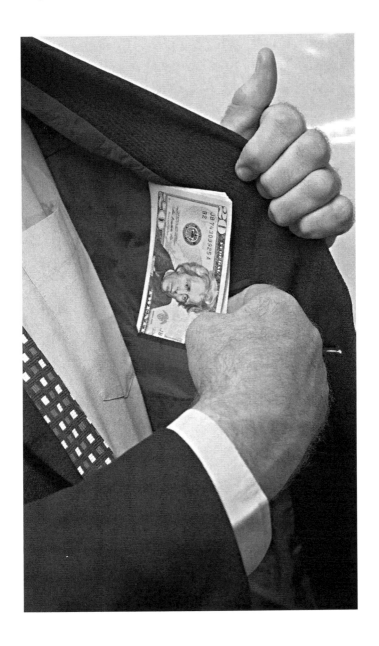

Toxic Checkup

This chapter's title is pulled directly and literally from Section 501(c)(3) of the IRS Code, the section that explains charitable organizations like your arts organization. As you begin your evolution from an art-first, solipsistic organization into the preferable community-first, charitable organization, you might want to perform a quick toxicity check on your board and executive director. There are some questions in the discussion pages immediately following this chapter to help guide you. Use them.

Find a Reason to Go Out of Business

In this section, when we talk about "going out of business," we're not talking about bankruptcy. We're talking about the opposite of that. For most charities, a completion of their mission might mean that the societal problem has been forever solved; this, of course, would put the nonprofit "out of business." What would the world look like if you somehow fully executed your charitable mission?

To wit:

- If people have enough food and need never go hungry again, we can go out of business.
- If people have the education they need to have a happy life and can continue to provide it for their progeny, we can go out of business.
- If people with intellectual and developmental disabilities can not only function well within the community, but teach the next generation how to function, we can go out of business.
- If the water and air are made permanently clean, we can go out of business.
- If we reverse climate change so that 10 generations from now, the sky will be the same sky that we see, storms

and wildfires are few and natural, island countries stay afloat, glaciers grow, the ozone layer is stable and robust, and important species grow their populations to unendangered statuses, we can go out of business.
- If we cure cancer, we can go out of business.

Art — visual, performing, literary — is glorious, or at least it can be. It requires an artist with the chutzpah to serve as the deity of an unexplored universe. The work of any good deity serves the people who consume what they do, not the deity itself. Art serves simultaneously as storyteller and story; it is neither necessarily linear nor beautiful. It simply is, and it is enough.

However — and if you take nothing else away from this book, take this to heart:

- A nonprofit arts organization is not art.
- A nonprofit arts organization is not an artist.
- A nonprofit arts organization is neither godlike nor mysterious. Irrespective of the "vision" of any artistic director, it serves a community with specific desired impacts.
- Art is. Artists create art. Nonprofit arts organizations use art to solve a problem. There's a massive difference.

So, board members, how do you define and measure impact? What is your goal, your measure of when you can go out of business?

A Mission Is Not the Same as a Mission Statement
Once you define it with your new stakeholders, you can craft a mission that matches the ideal version of your community, the version that made you start a nonprofit in the first place.

The well-worn metaphor is that the mission is God and the mission statement is the Bible. Another metaphor is that the mission is found in the amygdala, located in the limbic system of the brain, where innate reactions (fight/flight, emotions) occur. It's often referred to as a "gut response." The mission *statement* emanates from the frontal lobe, where planning, decision-making, and speech occur.

Most missions cannot be properly converted into mission statements. Emotional response often cannot be captured or defined. The best mission statements aim for the nearly unachievable, that thing that will put your organization out of business if it ever were achieved.

- Eradicate world hunger (not "feed people").
- Eliminate homelessness (not "house people").
- End poverty (not "give resources").
- Achieve racial harmony and equity (not "be inclusive").

And definitely not "create art," "engage people," or "entertain people," because none of those items point to the need for impact. As discussed previously, arts organizations do not create art that engages or entertains — artists do. The creation of art is easy (note: not all created art is good, but it is easy to create), but to provide impact is the job of every nonprofit.

In a perfect world, a mission statement would be written before the company has been created. It would serve as the catalyst to create the company … its "why."

However, if your nonprofit arts organization has only come up with a mission statement that describes what it does (the art) rather than why it exists (the impact), you may not even have a mission suitable for a charity.

So, you might be asking, what kind of impact can a nonprofit arts organization make?

Milk Crate Theatre serves the under-represented and virtually invisible people of its community, empowering them to create better lives for themselves in tangible ways.

A now-shuttered dance company in Florida worked with victims of childhood sexual abuse in order to allow them to transform their pain into personal power; there's a film about it from 2003, *Innermotion — The Dance of Incest*.

There are numerous arts programs in prisons.

Take a good hard look at your community's issues. Not national issues. Not even regional issues. *Your community's issues.* If you're having trouble finding out what they are, ask the community's leaders: political representatives, community service leaders, the clergy, the police department, hospital staffs, EMTs, and all the nonprofit leaders you can find. It probably doesn't serve you to ask the wealthiest among you – they don't use or need the services.

Research the community by examining surveys that have likely already been done. If they haven't been done, do them yourself. Here are some examples of issues, but there are many more that could be the most devastating in your own community:

Healthcare is expensive and often unattainable

Women can no longer find health clinics

Animals are being mistreated and filling up kill shelters

There are homeless people with myriad issues, including mental health

Gun murders

Massive wage and wealth gaps between the most and least wealthy in your community

A large percentage of kids go to bed hungry

Classic books are being banned

Schoolchildren who speak non-English first languages are being ostracized into "Special Education" classes, even though they're just as intelligent as English-speakers

Illegal discrimination occurs daily and harms people of all types, ages, and education levels looking for work

The stated plan for Artificial Intelligence, at least by Elon Musk, is to "come to a point when no job is needed – you can have a job if you want for personal satisfaction, but the AI will be able to do everything."

The US food supply is in the hands of just a few quasi-monopolistic companies

Social media doesn't really care about what's true, only what's popular

Kids interested in participating in amateur sports for fun and exercise have no place to play without cost

Hate crime against LGBT members, Jews, Palestinians, Black people, Asian people, Latinx people, and other non-White, traditionally subjugated groups is on the rise in your neighborhood, even from those hired to keep the peace

Those are just some of the things going on in the US. Narrow it down. There are specific issues to *your* community. Think about eradicating them. Or at least mitigating the damage. Use your art to make that happen. Simple concept, but difficult to enact.

You have likely never considered your arts nonprofit as a tool to solve bigger issues than the lack of art. Art is everywhere; there is no lack. But others have chosen the path of helping people live in a safer, better neighborhood. They have looked at the issues of safety and security, for example, and have found ways to use art as a catalyst for finding help. You may think it's a difficult task because it requires a completely different mindset for you and your artistic team. You'd be right. It may well be difficult at first.

But worth it, when all is said and done.

So, How Do We Derive Our Mission?

Ask these four questions:

- What societal problem will we eliminate for our community?
- Why is the production of your version of art a unique and powerful tool to use to *eliminate, or at least mitigate,* that problem?
- How will we know that problem has been mitigated successfully?
- What would be that defining moment when the company ends its operations because it has succeeded?

If you created your arts organization for the glory of producing art, just remember that it's easy to produce art. Two buskers performing on the sidewalk in front of your building qualifies as a competing arts organization. Especially if they have a hat or guitar case open for tips.

However, if you created your nonprofit arts organization for the purpose of producing art, you have failed in your responsibility to the community. Art is essential, to be sure. Your presentation of art is not essential at all. This might be why, only among nonprofit arts organizations, we have wealthy donors who are the beneficiaries of their own charitable support. The rich feeding the rich — the very definition of "elitism."

Board Membership: It's Not Just a Job, It's an Adv— ... Wait a Minute, It *Is* Just a Job

Board members need job descriptions and contracts. Even if they are trusted volunteers.

A volunteer is simply an employee that makes $0 per hour. Like any employee, they are subject to guidance, restrictions, and specific responsibilities and outcomes. Unlike almost all employees, however, any review of a board member's work

must be conducted by either a peer (a chair or an executive committee, for example), or worse, someone who *reports to them* (the executive and artistic director). A board member has no boss, *per se*, except an amorphous blob called "The Community."

In a US nonprofit, including arts nonprofits, the state charters the company to receive tax advantages in exchange for performing a public charity in a community. Its board members, as governors of the company, have the state-mandated responsibility to make sure the company does not divert from its intended purpose and enter into a profit-making or profit-shielding fraud.

You've identified a need, something that is hurting (or is destined to hurt) your community. You started a nonprofit to tackle that problem. The community, represented by the members of the board of directors, is in charge of making sure that happens in the best possible way.

But the community is not a person. Nor does it choose, assign, or review your board members. This is where it gets a little weird. The chief tasker for your board members is very often the person who reports to your board members, the executive (and sometimes, the artistic) director.

It's a neat little tango. But instead of "tripping the light fantastic," it more often causes just plain old tripping, falling, and landing painfully on one's posterior (usually the executive director's).

Maybe you believe the person in charge is the board chair. The problem is: if the person in charge is the board chair, then who assigns tasks to the board chair, especially when that self-same board chair may only be working a few hours a month for the nonprofit?

The person who often assigns tasks to the board chair, even in private, is often the executive director.

Then, the executive director reports to the board, who reports their tasks to the executive committee, which passes it along to

the executive director and staff, which reports to the board that tossed the dog that worried the cat that chased the rat that ate the cheese that lay in the house that Jack built.

When you draw up the board's responsibilities, use a #2 pencil. Bring a big, pink eraser, too. As times change and obstacles to success present themselves, a board's most important responsibilities must accommodate those obstacles in a flash.

A lot of board members take this information and still ask: "Do I have to donate cash money to my own nonprofit? I mean, in addition to the hours of work or expertise I provide, do I also have to give money, too?"

To which the answer is an unequivocal "yes." Nothing ambiguous there.

In fact, the nonprofit on whose board you serve ought to be among the highest amounts of money you donate to any nonprofit. Top three, to be sure. In addition, you shouldn't have to be asked for it, nor should you accept any benefits for it. If you require all that stuff, you're not really in it for the impact; you're in it for the status. That makes you a dangerously disconnected board member and risks breaking your board. And your organization.

In order to ensure that every stakeholder is on the same page, take time to truthfully, independently (in other words, not *your own personal* judgment), and ruthlessly evaluate why your board members are your board members. One of the best ways of doing this is to gauge the comfort level of what you are doing now, and why.

Are your services helping the community thrive? How? And how is the connection to that community — the board member — feeling about that? Does that board member ask for impact? Or do they concentrate on day-to-day financials? Do they just love art? Do they just like seeing their name on a plaque?

Or do they love the manner in which *your company's* art has quantifiably improved the lives of the people you claim to serve?

To zero in on that point, try to describe your nonprofit among these four terms: Important, Essential, Crucial, or None-of-the-Above. Which describes your nonprofit arts organization? And don't exaggerate — just evaluate where you are right now. If you can be honest, great; if you feel even the smallest pang, get an independent consultant, *and listen to that person.* In any case, don't try to guide others in their answers.

Important < Essential < Crucial — Choose "Crucial"

Is it difficult for you to comb your contact lists for prospects to support an arts organization? More difficult, say, than asking friends to donate so that a food bank can feed the hungry, or that a homeless shelter can put a roof over the heads of those that cannot afford it for a night, or that an animal shelter can save the lives of puppies and kittens?

There are things that are important, things that are essential, and things that are crucial. To artists, art is crucial; it's the basis of their livelihood. That's where the branch splits off — to the public, art is not crucial. It might not even be important to some.

To add to the dysfunction, the vast bulk of arts *organizations* in the US are neither crucial nor essential. As such, there is a growing segment of the population that bridles at the notion that they are, citing hunger and shelter as crucial and pushing the work of arts organizations to the children's table of luxury. To them – and they include leaders of other kinds of nonprofits – the arts are nice. Cute. Pretty. Maybe even inspirational. But among the choices above? They currently evaluate arts organizations as none-of-the-above.

The stakes have to be high for a problem to be considered "crucial." Your work on the board of a nonprofit arts organization, then, cannot simply be a status symbol, either for

you or your friends. The arts already have an "elitism" problem, as discussed earlier. Arts organizations without a crucial reason-for-being add to that side of the argument.

The Seminal Question, "Why are we here?", applies to every nonprofit arts organization. If the answer is simplistically self-facing ("We're here because we're here."), then the industry is pretty much doomed to insufficiency, no matter how "relevant" you tout your programming (remember, if you have to point out that something is relevant, it's almost certainly not).

Your organization does not get many chances to prove its worth; if you waste a chance on either vanity programming or forgettable entertainment, you've spent a lot of effort not furthering your mission to help people. As Lin-Manuel Miranda wrote in *Hamilton!*...

If you stand for nothing, what will you fail for?

Things will never "go back" to a pre-pandemic existence. This is not a new idea; it just happened in a trice instead of a generation. After all, you're not likely using a land line telephone with an actual dial on it either. People under 40 don't know what a "toll call" is, so an 800 number is irrelevant to them. In this context, though, your arts nonprofit can no longer be about what a particular group of bullying, elitist rich folks — or ivory-tower academics — want.

Consider — if the productions are merely beautiful and are not used to solve a problem in your community, is your organization acting as a public charity? If you're confused by the question, consider this definition by the *Cambridge Dictionary*...

Charity, noun. An organization whose purpose is to give money, food, or help to those who need it, or to carry out activities such as medical research that will help people in need, and not to make a profit.

... because *that's what people believe nonprofits and charities are here to do.* Even nonprofit arts organizations such as yours. With that in mind, think about what is important, what is essential, and what is crucial. And what is none-of-the-above.

Especially what is "none-of-the-above."

And Now It's Time to Earn Your Keep

When you've answered all those questions and believe you have the right people on the board, it's time to go to work. How effective a board member would you be if you believed that people lived or died depending on your participation?

You don't want an average board, an average organization, or have an average impact on your community. You want impact. You have a contract with your nonprofit arts organization that enumerates your responsibilities, the second most important of which is to raise money. No less than 80% of everything you do for your organization is about raising money. No worthy nonprofit arts organization needs your expertise on governance or art. They need money, and you're there to raise it; *both* from your own pockets *and* from the community — not one or the other.

Discussion Exercises/"... None of Its Earnings May Inure to Any Private Shareholder or Individual."

Quick toxicity check:

Is there anyone currently at your board table, executive office, or anyone else with even a modicum of unchecked, concentrated power?

How does that help or hinder the decisions your organization will make?

How does that help or hinder your ability to show quantifiable, charitable impact?

Will your future self (or your successor) thank you or curse you for the decisions you make about your organization's work right now?

What are your board's responsibilities?

What do board members do that staff members (including other volunteers) cannot do?

Why does the company need a board member to do that task?

How can we "hire" the best board member to fill that need?

How can we ensure that a board member will be as zealous (not merely "ambassadorial") in his or her duties as every other employee is expected to be?

Daily questions for your board members to ask as they judge their own development, their own toxicity, and the efficacy of everyone's work.

Do you give to this organization only because you're a board member?

Does your organization have to give you exclusive benefits in order to get you to give money?

Is your donation amount tied to the benefits offered? Would you give that amount anyway?

If your arts organization is performance-based, do you get better seats because you donate?

Does your organization have to ask you more than once to renew your tickets?

Do you believe (or were you told that) you're not there to raise money?

Do you ensure that your organization meets payroll?

Have you ever seen one of your company's performances and asked yourself, "Why am I here?"

Have you ever seen one of your company's performances and so reveled in the production that you told yourself, "That's why I'm here."?

Have you ever seen one of your company's performances and then asked any other board member, "How are we using this to serve people?"

Donate Now or We'll Shoot This Bunny

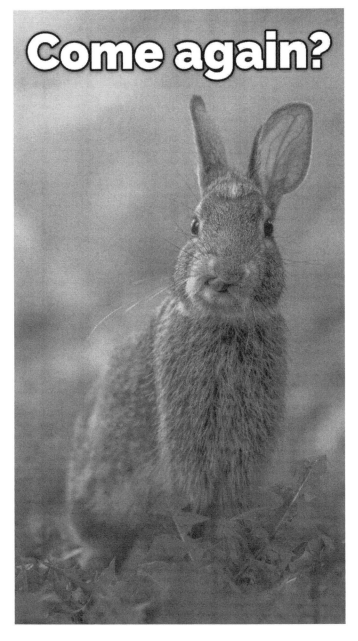

In early 2011, I stole an idea from the January 1973 edition of *National Lampoon* magazine and turned it into an ad campaign for my nascent consulting business. I created the worst, most tasteless fundraising campaign I could imagine. It was meant to be crude, over-the-top, and ridiculous. I sent out over a thousand postcards to a list I had composed of every arts organization in the United States. On one side, the post card looked like this:

The text on the other side of the postcard said:

BEFORE YOU RESORT TO THE "DEAD RABBIT" CAMPAIGN, PUT THE GUN DOWN AND CALL ALAN HARRISON.

Stop writing panic letters to your board. Instead, put a real revenue plan in motion. Based on mission, action, and outcomes. Not on guesses, assumptions, and "we-do-it-this-way-because-we've-always-done-it-this-way."

A failing action plan doesn't magically start working just because you're doing it harder, louder, or with more anxiety. When cash becomes king, innocent rabbits die.

And do you want the demise of furry, woodland creatures on your conscience?

(Note: no animals were harmed in the making of this card.)

I got a lot of phone calls. (People were still using the phone in 2011.) I also got plenty of e-mails and social media responses. Some executive directors and development directors said they tacked the card up to their bulletin board. Others laughed and thanked me for that. A few others asked about my services and I set up several clients by virtue of that campaign.

Still others complained that it was cruel and vulgar. I tried to reason with them.

"It was *satire*," I explained. "It was only a *picture* of a gun and a *picture* of a rabbit. At no time did I put an actual gun to an actual rabbit's head. And did you read the text on the back?"

Not listening, they continued their respective diatribes until they were too tired and angry to continue. Then they either hung up or signed off. When they were on social media, the storm brewed anew. Some of the people who read the complaints sided with them; others couldn't believe that they'd all become Emily Litella, Gilda Radner's *Saturday Night Live* character of an older woman who was always delivering outrageous, angry responses to mis-heard editorials on the "Weekend Update" portion of the show.

*What's all this fuss I keep hearing about violins on television? Oh, **violence**. That's quite different. Never mind.*

But the most frightening responses I received, and there were way too many of them, were board chairs who asked permission to use the campaign for their own arts organizations. Desperate for cash, these were people who did not think it was satire at all, but instead believed it to be the best way to get dollars through the door. They were totally serious.

And these were just the people who *bothered to ask* instead of stealing it outright.

The point is this: when a leader presses for a better outcome without changing the way in which that leader's company does business, it is tantamount to telling someone, "If at first you don't succeed, hit it harder. You're just not hitting it hard enough."

The worst nonprofit arts administrator in the world (in my opinion, of course — you might know worse) was Bill Bushnell, for whom I worked at the Los Angeles Theatre Center, which closed down with $29 million in debt. After that, a university hired him. To teach arts administration. Then I believe he moved to St. Croix, reportedly owing thousands to the government for not paying unemployment taxes. Allegedly, of course. All this might be completely made up, my lawyers have asked me to write at this moment.

His greatest "talent" involved over-promising, under-delivering, and deflecting blame onto the lenders and vendors — much like an evil carnival barker. He delighted in maliciously bullying his people into accepting impossible challenges and berating them publicly when the challenges couldn't be met because, as described before, they were "impossible."

For example, before that last season, he presented a season budget to the board — without any input from anyone — that called for a 33% increase in ticket revenues and a 40% increase in donated revenues. The plays were mostly new, untested works, several with full frontal nudity, just like the previous year. One was a big hit in Iceland the previous year. Yes, Iceland.

There were no stars or any other special feature to them. When I, the marketing director (egged on by the overly competitive and not-very-talented development director, who didn't want to appear adversarial for her own political reasons), simply

asked, "Based on...?", he gleefully snapped, "That's what it's going to cost to do *my* season! Idiot!"

His season.

This all happened at a theater where my marketing prowess led to the highest subscription retention rate in the company's history in its Skid Row building at 5th and Spring, where hookers and drug dealers swarmed the front door all day and all night (not actors and actresses *playing* hookers and drug dealers). That renewal rate? 26%. And this was in the early 1990s, when people still subscribed to things.

The board of directors thought he walked on water. Until the bankruptcy cost each of them a whole lot of personal dollars. Millions.

The second worst arts administrator in the world, in my opinion, is probably still around, so he'll go nameless here. This gentleman chose to blow up the marketing, PR, and production budget on a certain title in his first season because he had been so adamant about scheduling it. On the marketing and events budgets alone, he spent 150% of the ticket revenue.

For every $1.50 that was spent on marketing, $1.00 was expected in revenue.

You might be asking, snarkily, "Is this one of those jokes where the guy loses money on every used car he sells, but he says he makes it up in volume?" You'd be correct.

It would have been much cheaper and more efficient to give the tickets away. And, in hindsight, free tickets to the right people might have diversified the demographic disposition of the audience, if it had been done smartly.

That year, the company ended in a surplus, amazingly, because of two separate million-dollar gifts that the marketing and development team (joined together as a single department) were able to muster in a hurry. And, with three months to go in the fiscal year, that bungling arts administrator unceremoniously

fired everyone around him, including the marketing and development director (to keep expenses down), while retaining his $200,000 + salary, benefits, and car. As did his partner, even as they laid off staff.

The board at his organization, too, thought he could do the loaves and fishes thing. They probably still do. Instead, he's just another flimflam man.

How to Hammer a Nail with a Salami

It's tricky to set revenue goals for nonprofit arts organizations. Each production is new and untested, and is either good or bad on its surface. It's analogous to a company introducing a new cola for sale, removing it from the shelves entirely after six weeks, and then introducing an airplane for sale.

Popularity is only so predictable. A good marketing person forecasts based on similar titles, similar reputation, time of year, place in season, and myriad other factors. Then, a mediocre executive director (usually not a marketing mind) hammerlocks the group that forecast the revenues into increasing their projections, sometimes by a whopping amount. Revenue teams go back and try to find a way to hit the new goal (higher prices, more donations, etc.), which placates the executive until the end of the fiscal year, when the board comes down on the executive director about why productions didn't hit their forecasting goals. At this point, many executives fire their marketing and development teams, the ones who may have projected the correct (as it turned out) outcomes in the first place.

Many executives throw their marketing and development professionals under the bus, and that is why the area under buses is lousy with bewildered marketing and development professionals.

Have you ever been a leader who looked at a hard problem and demanded someone else solve it — because you can't? Then

became angrily inconsolable when it couldn't be solved using your parameters?

Have you ever been the someone else designated to solve a problem, but the problem was unsolvable without radically changing the parameters of the problem (by lying about it)?

Regardless of your position, you have probably asked, or have been asked, to solve an unsolvable problem.

- Make 2+2 = Newark.
- Sell 125% of your product's inventory without making more of it.
- Hammer this nail into a board using a chub of salami. If the nail doesn't go in, just hit it harder. If that doesn't work, you're fired.

By the way, here's how to hammer a nail into a board using a chub of salami.

1. Put salami aside. Get a hammer.
2. Using hammer (not salami), tap nail into wood, increasing strength of tap as the nail sinks in, until nail is fully in wood. Then stop hammering.
3. Cut salami into thin slices; add Swiss cheese, mustard, and sauerkraut; put between two slices of fresh caraway rye with a cornmeal crust; cut in half; and enjoy on a nice plate with a potato salad, a half-sour pickle, and a nice glass of Dr. Brown's Cel-Ray Tonic. If you're from California, add lettuce, tomato, and avocado.

The point is, while you should never present a problem without a solution in mind, sometimes there is no real solution. At which point, a good leader will find a way to support the people who deal with the consequences of a bad decision, or a bad leader will get rid of those people (or watch them resign).

SCENE CHANGE 2

If good people are resigning because they don't like working with you, it's not about them. *It's about you.*

Starving. Just Like Everyone Else.

On the artistic side of organizations, much is made over the fact that artists cannot make a living at what they do best. You've likely heard this from your artistic leader, especially if that person is also the titular company executive. The truth is, scarcely any artist has *ever* made a living doing what they do best.

Some have, to be sure. Like professional athletes who are arguably the .01% most talented in the world at what they do, only a few artists of any kind actually make money. That's why you hear the phrase "Starving Artist" but not the phrase "Starving Cybersecurity Expert."

Your donation to your arts organization filters down to the artists, of course, on a project basis. Every artistic director with which I've become acquainted doesn't seem to understand that in most cases, artists are hired on an ad-hoc basis (weekly salary for the term of the engagement + rehearsals) and their weekly salaries during that time are often equivalent (or more) than the administrative artists lending their expertise toward operations success. But never mind that, for now. Artists starve. That's a fact of life.

Today, in the aforementioned Pre-Post-Pandemic Era, artists are starving more than usual. *Just like workers in other industries.*

There is even less work than usual. *Just like in other industries.*

Artificial Intelligence (AI) is reducing the number of professional artists necessary for a given project — *just like the reductions in other industries.*

In the *Los Angeles Times*, Carson Elrod, co-founder of Arts Workers United, warned:

The theater is not a cause or a charity or sort of feel-good peripheral thing. We're an integral, dynamic cornerstone to economies all over this country; we're one of the nation's biggest exports. And if we're not doing what we do because we end up doing other jobs, the greater American economy will suffer.

Always remember that supporting a nonprofit arts organization that has no palpable, quantifiable impact on its community is a fool's errand — which is why funding has dried up since the pandemic forced funders to infer that arts organizations were not "essential businesses." And *that's* why fewer artists are getting paid.

Outside of a very few, no one cares if your nonprofit arts organization closes except its current staff, leaders, board members, artists, and its core audience. In other words, the inner circle cares, but no one else. Politicking folks may experience temporary wringing of hands in support of the arts as a whole, but only for show, and almost never for a particular arts organization.

Sadly, nonprofit arts organizations across America (and beyond, one frets) choose to mirror their counterparts in the for-profit world. In a *for-profit* arts project, the consumer is the ticket-buyer. It's a straight transactional relationship — money for ticket, ticket for experience. Show's over? End of contract. No public good intended or given. And no further action — donations or otherwise — need occur. But hey, buy a $10 coke and a $50 T-shirt.

When the relationship is merely transactional, community impact cannot happen. That kind of impact comes to those who have need, not those who have purchase power for a ticket.

To put it another way: does the cooking of food help to mitigate hunger? The presentation of food? Even if the food is of excellent quality?

No. The cooking and presentation of excellent food only helps to mitigate the absence of cooked, presented food.

The consumption of food mitigates hunger, regardless of a chef's depiction of excellence. And if starving people won't eat your food, they'll die.

Let's say your community crises are centered on racial intolerance toward Black people. Even if your key members of your community do not recognize that racial intolerance is a harmful thing — as I experienced in Alabama — that does not lessen these crises. In fact, some would argue that the crises have become exacerbated by the lack of care taken to mitigate (or better, eliminate) the problem.

As a nonprofit theater arts organization, you might choose to put on a Black play once in a while. You might even have post-show talkbacks with members of the Black community (not my personal preference, because, for me, if the message is not evident in the play, it's hard to justify bringing it up in a talkback). But when the production's engagement ends, does the relationship with the Black people involved with the production (on both sides of the footlights) also end? Or does the relationship devolve into asking patrons to buy subscriptions? Donate? Both?

How does that mitigate or eliminate the crisis of intolerance toward Black people in your community? Or does it serve just as a societal band-aid that makes you feel better about your work?

A radical idea might be this: instead of producing one Black play, produce several. In fact, you might consider producing *only* works that speak to intolerance until the problem is mitigated.

Do it until the flywheel of change has started spinning to mitigate the crisis on its own.

To be clear: popularity, by itself, is not in opposition to your ability as a nonprofit arts organization to produce impact. In fact, it can amplify the impact ... for a time. At some point, theatrical organizations started putting together adaptations

of Charles Dickens' *A Christmas Carol* because they knew the story was popular (and would be a surefire ticket seller), and because they knew the message of the perils of miserly behavior was important to the moral health of a community. Today, the last part of that description is somewhat moot, as everyone knows the story, the message, and the importance of charity; *A Christmas Carol* now leads the pantheon of Christmastime Cash Cows.

Ironically, this story of the power of charity is being produced almost always by charitable organizations that do not produce the kind of charitable impact for which charities are required.

The selling of tickets is a choice, not a measure of success. Selling tickets does not make a nonprofit organization impactful, even if you sell a lot of tickets. Selling tickets, as mentioned earlier, is a transaction — no more, no less. When you base the success of your business on a series of transactions — be they individual ticket sales, subscriptions, and even most donations for which a donor receives a special benefit — you have chosen to place popularity *above* impact. This is not what your community wants, and, as the owners of your nonprofit, it's imperative that they have the final say.

A desperate community needs tangible help. If your art can serve as a tool to provide that kind of help, you will succeed. Otherwise, it's irrelevant, no matter how excellent.

And why in the hell would you choose irrelevance? Or is it more important that you get the donation, even if it threatens a picture of a cute little bunny rabbit?

There's Impact, and Then There's Impact[2]

But now, you may be thinking, is the worst time to raise money ever. At least until the next worst time to raise money ever.

So what do we do in the face of that? We might decide that a bad economy gives all the stakeholders an easy out, a way of easily, blithely, and almost eagerly deciding not to raise

the resources that it takes to achieve greatness. An unstable economy allows us, perhaps, to agree to failure.

The fact is, we too often sacrifice greatness in our work for survival. Survival, believe it or not, is not the mission of any nonprofit arts organization, nor should it be.

How people interact with their finances is not merely an arithmetic process. The study of behavioral economics goes back to Adam Smith, when he proposed that charity — and nonprofit arts organizations are charities, folks — is innate to humanity:

> *How selfish soever man may be supposed, there are evidently some principles in his nature, which interest him in the fortunes of others, and render their happiness necessary to him, though he derives nothing from it, except the pleasure of seeing it. Of this kind is pity or compassion, the emotion we feel for the misery of others, when we either see it, or are made to conceive it in a very lively manner. That we often derive sorrow from the sorrows of others, is a matter of fact too obvious to require any instances to prove it; for this sentiment, like all the other original passions of human nature, is by no means confined to the virtuous or the humane, though they perhaps may feel it with the most exquisite sensibility. The greatest ruffian, the most hardened violator of the laws of society, is not altogether without it.*

People who can afford to give to your organization, who have been *inclined* to give to your organization, and who may *have given* to your organization, can afford to serve their "principles of nature" by giving again to your organization...

... if and only if your organization deserves the gift.

As we've said, over and over, impact is the key. But the impact of the impact — aka "Impact Squared" (Impact2) — is even better.

Impact2 is the impact of the impact of your programs. Simply put, the best thing your cause can do for your community is

to do the kind of good that, in turn, provides even more good. What Impact2 requires is a ton of research on the results of your activities. Real research. Even the kind of research that doesn't show any particular program in a good light.

Here's how it works. Let's say you run a food bank in a major city. Last year, your company fed 100,000 people. Good job. That's your impact.

Now, let's say you tracked those people. As much as possible, you developed relationships with your users. And let's say that your research proved that 40,000 of those people took advantage of the food bank as the scaffolding to get them beyond unemployment and eviction, and are now back to work *because of your food bank*. That dependent impact — a return to dignity and society — is your Impact2. Impact2 makes your nonprofit more valuable than you even knew, especially when it's intentional.

Think for a moment. If you ran that food bank and your company's "why" was to feed people who cannot afford it, and you did that, you'd have gotten the equivalent of a C for your efforts. Solid.

If, however, your company's "why" was to dignify those who have hit on hard times and lift their lives out of poverty and back into society, and you did that through your Impact2, you got an A. But only because you measured and proved that.

We can quantify Impact2. It might become our saving grace. Because as long as we continue to promote the arts as an inherent good without explanation, as an unquantifiable "nurturer for the soul," we will always struggle in our attempts to insure resources for ourselves.

It is not as though all the money in the world has suddenly vanished. It has not. American companies are sitting on the largest stockpile of cash in the history of the United States. Average Americans still spend a great deal of money, so

much so that it has been deemed "disposable." Some social service agencies have had their best fundraising years in their histories.

The money is out there, waiting to be spent. Support is there for unrestricted funding that might become an object not of art, but on the Impact[2] of the art. Can you positively assert that lives have become better because of the Impact[2] of the art you put on stage, in a gallery, or in the concert hall? If you can't answer that question, you might still be floundering even as the economy brightens.

Your Gala Is Not All That Effective

I was talking to a good friend in the nonprofit arts business. At one point in the conversation, she started speaking in low tones as if someone at the next table were a spy.

"We're in the run-up to our next *gala*," she told me under her breath. "There's no way we can raise the amount of money we have budgeted, not in this climate. There are just *too many auctions* going on."

She even stage-whispered the words "gala" and "too many auctions" in the same way people stage-whisper "cancer."

What's odd is that just about every development professional I've met in the last ten years has told me what a nightmare auctions and galas can be. Those who depend on more than 5% of their annual revenue budgets on one night of a gala are in sheer terror all year long. Those that do it just to have a party and thank donors have a different tack — it's great if it makes money, but as long as it doesn't lose money, it's all right.

These days, auctions and galas have mostly become old hat. Development directors across the country have come to resent the pressure on one night's earnings, the pressure to provide a great party, and the further reputation disrespect of the development department as "party central."

It makes sense. Development departments don't want to spend thousands of hours of procuring; paying the hyper-inflated prices of venues, caterers, liquor, and entertainment; or risking the budget on a single night that might be a victim of weather, scheduling, a bigger auction elsewhere, or the health and caprice of the auctioneer, biggest donor, or venue operator.

Imagine how many connections could be reached if all those hours were spent on real development activities.

Development efforts require excellence year-round. It takes time to develop contacts, develop relationships, do research, and ultimately ask for a donation. And even more time following up: talking to them about things that have nothing to do with fundraising, asking their ideas (and taking some), and doing all the real work that a good development effort does.

The one-night auction is not a strategy. It's just a swing for the fences. And like any baseball player who only tries to hit home runs, you'll just strike out a lot.

The Circular Firing Squad

Nonprofit arts organizations have not cornered the market on bad leadership. There are lousy leaders in every industry. Even leaders who make profits can be horrible human beings. There is no correlation between success and morality.

But you already knew that.

Still, in the nonprofit arts world, when a leader is lousy, way too many people suffer the consequence.

Thirty years ago, Gwen (not her real name) left a hugely successful marketing and communications job in one city to become the marketing and communications director for a larger, venerable nonprofit theater organization in another city. Her predecessor had blown most of her marketing budgets on special events during productions, trying to sell packages that included food, drink, and entertainment. The development

director, Sandra, also threw special events, often on the same nights, also including food and drink, in order to woo or placate her donors (or potential donors). In neither case did the special events have anything to do with the performance. The company was a bit of a country club, as are many, if not most large arts organizations. Wealthy. Highly educated. Older and White, almost exclusively.

Diversity efforts, even back then, were mostly geared to get people of color into the hall by programming one Black event per year. It was usually an agreed-upon classic or a small, cheap musical. In the 1990s, it became the latest August Wilson play. Eurocentric behemoths such as this particular theater produced his works and trumpeted their "universal" themes. Calling art "universal," while promising a broad appeal, often has the reverse effect. If they had called it a Black play, they might have scared off those traditional, old, White audiences and donors. By calling Wilson's plays "universal," these organizations let White people know they were safe, and in doing so, let Black people know that their intent as an organization was simply to present, not to make things better. Wilson furthered his career financially by this distinction but, to his credit, did everything he could to have his plays produced at truly Black theaters, where, as he described it, all productions were "1) about us, 2) by us, 3) for us, and 4) near us." But, not being unintelligent enough to be wowed by a White theater's production of a "universal" Black play, Black people chose not to come to a building that did not regularly welcome them (because if they had, that might send the White folks scurrying to one of the several other large arts organizations).

[August] Wilson's choice to use universal themes and character types in his work has benefited him greatly in the mainstream theater. His answer to the question of African American representation is one that does not strike at the nerve of mainstream

theater audiences. Instead, he chooses to present figures that can be considered universal "everymen" and women and to focus on themes that can come from every culture of American society.
— *Ladrica Menson-Furr, PhD,*
Associate Professor Director of African and African American Studies,
University of Memphis

The company's all-White, well-meaning artistic team did not understand why there were no people of color in the audience. Thinking they were oh-so-progressive, the company forced each volunteer usher to have a counter in his or her hand, and click every time a Black person walked in. They called it a "B-count." Still, the company's leaders blamed the highly-skilled Gwen, the marketing director, for the Whiteness of the audience because they believed that she was responsible for selling tickets to the "right" people, regardless of the programming. Gwen knew what was happening, why, and had advised all relevant parties of the issues of this Eurocentric theater well ahead of the production's engagement.

The experienced (but self-serving) Sandra — pitted against Gwen by an unqualified executive director to try to shame her staff into raising more money — was only too happy to giddily chime in and try to play the hero in attracting a diverse audience.

She applied to a major organization for diversity funding for a marketing initiative (which Gwen never saw). After submitting the official Letter of Inquiry, the foundation sent it right back for revisions. They wanted to know the specific expenditures that would be made with the donated funds. The artistic team patronizingly stepped in, forcing the company to devote the entirety of the funding toward production expenses and actor salaries for the one Black play (rather than, say, marketing and relationship-building for a series of Black plays, Latino plays, etc.). Surely, Black people would be impressed and attend all the plays the theater would ever produce. Even

those by famed, dead, male, White playwrights Henrik Ibsen and Noël Coward and William Shakespeare, with all-White casts.

The million-dollar grant, surprisingly, happened. The new Black audience, unsurprisingly, did not.

Additional involvement with the town's Black community was deemed not the purview of the artistic and production staff, so few additional efforts were made to woo them. Had the nonprofit's leadership been an executive director, instead of an artistic director, mission execution might have superseded artistic staff dismissiveness.

Because the attempts to gain community were, in fact, attempts to gain audience members and revenue (and therefore were transactional, not inclusive), the audiences did not change. There were no Black community locals involved with the production itself. The Black community just looked at it as another empty-headed, arrogant, White-guilt gesture to gain their trust.

Leadership blamed Gwen, of course, at a board meeting, right after the run of the Wilson play. It garnered abysmal sales numbers, which in hindsight, was completely predictable.

Gwen could not quit her job fast enough. She was replaced by another skilled marketing director who left in six months. He, in turn, was replaced by another skilled, but inexperienced marketing associate, who was lured away in eight months. Sandra, on the other hand, became a development director icon whose brutal tactics were admired by members of the board she had so weaselly wooed and coddled, relegating any complaint about them as "sour grapes." Sandra teaches now.

Have you ever heard of a circular firing squad? A circle of shooters aiming rifles at each other, with a commander yelling, "Ready, Aim..." Too many large nonprofit arts organizations have adopted the circular firing squad as an organizational model.

The circular firing squad in which nonprofit arts organizations willingly participate is all-too-prevalent among organizations with bad leadership. It especially adversely affects larger organizations, where the leaders are goaded into the worst possible siloed behavior; which, in turn, emanates from a leadership void, or worse, a leadership abdication. And it's easier to hide in a larger organization than a compact one.

Every. Single. Company. Talks About Silos and Fiefdoms as Though the Metaphor Were Just Invented.

When companies are self-destructive and unwilling to work together; when managers of different departments snipe at one another; when executive leaders and board members encourage (or at the very least, don't discourage) implosive business behaviors — as in all issues that make no sense whatsoever — you have to ask, "Who benefits?"

Bad leaders benefit from silos and fiefdoms, that's who.
Badly educated and poor producing executive directors, artistic directors, board chairs, and longstanding department heads benefit. No one else. Why?

Because backstabbing, sniping, and self-serving double-talk are the tools of the intellectually incurious, the boor, and the bully — and the technique works frighteningly well to bring potentially good leaders down to their hideous level.

How do you identify a bad leader? Annual job evaluations are not the answer. Manipulative people breeze through them. And besides…

The way human beings make progress is through small steps, not through a bizarre, constrained [performance evaluation] once a year.

— Robert I. Sutton, PhD,
Organizational psychologist and professor at Stanford University,
author of The Friction Project:

How Smart Leaders Make the Right Things Easier and the Wrong Things Harder

But this is not about the ridiculousness of annual job evaluations either. *Your company should have stopped having those harmful meetings years ago.*

Multitudes of companies, both for-profit and nonprofit have seen them for what they are — an old, hierarchical method to keep workers scared and in line. They're an old vestige of the top-down, military culture that pervaded the US under Eisenhower after World War II.

This is about real, honest-to-Pete *leadership*. The kind of leadership that sees the threat of shooting a photo of a bunny as satire, not something one should actually do.

There is no magic wand that can cast someone as the inspiring leader of your company. So many pieces of the environment affect leadership characteristics that a great leader in one organization — a galvanizing influencer who motivates others to create the kind of nonprofit that works — might completely fail in a dissimilar situation.

Leaders of arts organizations — and you don't have to be the head of the company to be a leader, but if you are the head of the company, *you had better be* — your task is more desperate than ever. In the current standard way of producing "art for art's sake," you'll continue to try to find better ways to beg for money (and fail). You'll continue to barely keep attendance from bottoming out (and fail). All this will happen as long as you continue to choose "excellence" as the watchword of your exhibits/performances.

Excellence doesn't matter. What are you doing to quantify your help to your community? That's what matters, and that's what everyone's asking about your company.

If you'd rather do "excellence" than "impact," form a circle. Ready. Aim. Fire.

Sometimes, Less Really Is More

Large organizations and smaller organizations own different responsibilities in your community. That doesn't mean that someone who leads a large nonprofit arts organization cannot lead a small one, but it might, depending on the leader. The opposite is equally true.

Remember this:

A large nonprofit arts organization is no more likely to have a quantifiable impact on a community than a small one. In fact, a large nonprofit arts organization is more likely to have less impact per dollar spent.

Don't just dismiss that idea out of hand. New foundation and community leaders certainly aren't when considering whom to fund.

Large arts organizations sell more tickets. Raise more money. They have powerful board members, famous artists, lengthy institutional histories, and built-in media connections.

But impact? On the community at-large? The results are in and it's not even close.

Number of audience members does not constitute impact, otherwise the Los Angeles Dodgers could be a nonprofit.

Powerful board members do not constitute impact, otherwise Goldman Sachs could be a nonprofit.

Lengthy institutional resumes are irrelevant. Just because your organization is old doesn't mean you're effective today. I once went to the "oldest Chinese restaurant in Pittsburgh." They put Campbell's condensed cream of chicken soup over rice and called it Mandarin Chicken. It was truly awful.

"Oldest" doesn't mean "best." It just means "oldest."

Media connections are less persuasive now that everyone can have a channel (and so few people read a newspaper), so raves and pans mean almost nothing outside of New York.

And what organization would ever choose to be "venerable," a "flagship," or "established?" These are horribly dated words that shout "IRRELEVANT!" to the community in today's world.

In today's world, "feed," "heal," and "solve" are much more powerful words to live by. And smaller, nimbler, and more forceful nonprofit arts organizations have a much better chance of creating impact.

Discussion Exercises/Donate Now or We'll Shoot This Bunny

What's the worst idea that you thought might have been a great idea?

Why did or didn't it work?

Do you cause others to do relatively impossible tasks because you can't do them? (Do you ask them to hammer a nail with a salami?) What happens when they predictably fail?

How is your process effective? How do you accomplish impact?

Provide a flow chart that takes you from the production of art to the one or two issues that you have decided need to be resolved.

How will your nonprofit solve that problem effectively, and if possible, with some permanence?

Is there an Impact2 to the results of your work? What is that Impact2, and were those results intentional or accidental? If accidental, can you make those results intentional, and in doing so, can the Impact2 become the goal rather than a by-product?

Is the process repeatable and shareable? Is there a way to freely make your success available to any 501(c)(3) arts organization or any community?

What stands in the way of using your process again? How can you continually refine it to suit the needs of your

community? How does your produced or exhibited art play a part as a catalyst?

How do/will you measure your impact and publish the results?

Will you be measuring using positive data ("X% more people were served," for example) or negative data ("ISSUE was reduced by Y% because of our work")?

Will you be working with a foundation partner on issuing the results? If so, who and why would they want to partner with you?

Where will the data be presented? At a conference? Annual meeting? Website? Press release? Podcast? All of the above? None of the above?

How will you ensure that people of historically underserved backgrounds are served?

Is your company achieving pay equity among its own employees? What stands in the way of that?

What is the makeup of your community? Are there pockets of people who are unrepresented by the work you do? Why?

What is your community makeup?

Ethnic demographics:

Age (by range):

Education aspiration or achievement:

Race:

Economic levels (wages, home costs, poverty level, homelessness, hunger, etc.):

Religion:

Other category:

Other category:

Other category:

The Five Responsibilities

Caution: Do Not Proceed Unless Prepared

I knew it.

To those who started at the beginning, thank you for your attention. You're a wonderful person, among the greatest that ever existed. Oh, and so attractive, too! If you would be so kind, please just hang on a moment.

To those who decided to skip all the chapters that came before this one, I knew you'd do that.

To that latter group, I urge you, please: *don't jump straight to this section. Start at the beginning.*

If your reading starts here, you won't completely understand why these responsibilities are the responsibilities. Without context, this list may come across as arbitrary, brutal, or potentially incoherent. The first part of this book (and, frankly, the first book in the series, *Scene Change: Why Today's Nonprofit*

Arts Organizations Have to Stop Producing Art and Start Producing Impact) provides that crucial context.

Don't fret. Just go back to the beginning. Join the aforementioned attractive crowd. The first part of the book is a fairly quick read (and entertaining) so obey the speed limit and start fresh. It won't take long.

And Now, to Everyone:

Please take these recommendations as they were intended. Think of them less as hard-and-fast rules, and more as a list of key elements of a successful board of directors for a nonprofit arts organization. There are five responsibilities listed. You may have a few more than that for your particular organization. In fact, you will probably want to tailor these responsibilities specifically to the work you do for your community.

Beyond that, let me provide one more caveat: small organizations and large organizations have different kinds of people doing the work of the board. A smaller organization, still using board members as volunteer staff, may see these recommendations as overwhelming or discouraging. A large one may see them as picayune or elementary.

Here's the deal. Regardless of how you view your own organization's absorption of these responsibilities, the core elements of them are the keys to your success in helping people in your community overcome the issues that are currently plaguing them.

The reason there are books about board responsibilities is that there are no rules listed for board members anywhere in IRS code 501(c)(3), the section that defines and describes what activities allow a company to have a tax-exempt status. And, because of that, there are myriad arts organizations (maybe even yours) that may have been formed for the sake of the community, but have, over the years, become insular, defensive

organizations with a dash of paranoia about the quality of the art they produce, rather than the purpose.

One theater administrator I know uses four questions as guideposts to success for their nonprofit.

1. Are we laser focused on quality? At its most basic, a play must be good.
2. Are we centering our audiences? Do we ask, who are we making decisions for — the people in our theaters and communities or someone else?
3. Are we offering a competitive advantage? A night in our theaters must provide something that our audiences could not get elsewhere.
4. Are we producing plays to tell people what to think, or rather, introduce them to the more nuanced, complex, and intricate areas of life?

If these are the questions you use to determine your nonprofit's impact, you might be careening toward a spectacular crash. However, if your organization is a for-profit arts company, these are great questions to ask.

The one and only legitimate question for any nonprofit of any kind to ask is this:

How is our community specifically made better by the work we do?

That's all that matters to your community. And, as such, it's all that matters, period.

Responsibility #1: Determine Why the Company Needs to Exist

There's a handbook still being published by BoardSource, *Ten Basic Responsibilities of Nonprofit Boards*. You might already have a copy of either the original (2009) or any of its revisions. It's a good book. The kinds of responsibilities are what no one would call illegitimate or wrong.

In fact, the title, which isn't **The** *Ten Basic Responsibilities of Nonprofit Boards*, indicates that the author, Richard T. Ingram, understood the malleability of your plight as a nonprofit. Your own individual nonprofit may require more than ten responsibilities. Or, your nonprofit may require ten, but not *these* ten. It leaves the options open.

The analysis of the Dead Sea Scrolls showed that the translation of the first three words of the Torah/Bible are

more likely "In a beginning," and not "In the beginning," which might change the whole idea of a single beginning. In the same way, *Ten Responsibilities* is far different from *The Ten Responsibilities*, which connotes a finite set; that said, if it were *The Ten Responsibilities*, it would connote that these would be a foundational ten responsibilities, to which others may be added. Kinda like the book you're reading right now.

Back to the BoardSource book, it is thin on specific responsibilities for nonprofit *arts* organizations' boards of directors. In arts organizations, board members are too often major donors with major designs on powerfully pushing the framework of the organization to fit their wishes. And, too often, there is no real mission to the nonprofit (except to do "art for art's sake").

The lack of a real, tangible mission that aims to eliminate a social issue (or at least mitigate it) can lead to parallel universes within the organization. One universe, made up of the board members, wants to connect with the artistry of the company, but as a "power user," a special category of One-Who-Must-Be-Obeyed. Their dreams and ambitions for the company may or may not improve the company's work, but will certainly enhance the board member's value. Without a mission as a rudder, these self-anointed ones might steer the company into waters they know from their own experiences. As a result, you often hear board members grumble about how "this company should run more like a business," a phrase that is indefensible in its outrageous combination of arrogance and ignorance.

Incidentally, the next time you hear someone say that your nonprofit should "run more like a business," remind them that 95% of all businesses are mediocre. Ask them if they want a charity to be mediocre, too. Should a food bank be mediocre? A suicide hotline? What about their next heart surgeon?

The other universe, made up of the staff and artists (often interchangeable), wants to connect with the community and

sees the board members as conduits to that end. But, again, too often, they act like lazy realtors, showing the joys and excitement of the art and none of the mouse holes in the floorboards of the organization. Still, they'll do their little show at each board meeting so that the board members feel more connected to the art (art as reason for existence, not as a tool for community betterment).

Honestly, if your company takes even five minutes of precious board meeting time to see art in action (either by performance or exhibition), you have two parallel universes. It might be a good time to start over with describing your company's real mission; and not a self-facing one such as "We do excellent art so you should support us." The former head of ArtsFund once lamented to me that this sentiment was at the center of almost every mission statement of every arts nonprofit he was given to evaluate for funding.

The barrier to entry for arts organizations is lower than low. Anyone can produce some sort of art, anytime, anywhere. If a troupe of actors shows up on your venue's sidewalk performing Shakespeare, your company has competition. Frankly, if a troupe of *accountants* shows up on your venue's sidewalk performing Shakespeare, your company has competition. The need to exist, then, cannot be tied into the art your company produces. (Note: it doesn't create art. It produces it. There's a difference.)

Your community, however, has provided you with a gift: a barrier to entry that would be daunting to anyone else trying to compete with you: a need. The need is not a simple lack of art in your community. There is no lack of art in your community. Look around you. From the shape of your chair to the design of a white, Styrofoam cup, art exists. All are artful things. All have been designed. The artistry of design attracted you to them. Art is essential. Like air, art is everywhere, whether you like it or not. In the literal sense, art is essential, because art is inescapable. Without it, well ... there is no "without it."

It's everywhere. Like air. The only place art does not exist is in a void.

Happily, and I think I speak for everyone, we don't live in a void.

Art and *artists* are two different things. Artists create art. Artists designed your chair. Designers constructed that white, Styrofoam cup. If there is magic in the world, it is that artists create art. An artist takes an idea or a set of seemingly random objects and thoughts, uses skills (either innate or taught) and creates a *thing*. Sculpture. Tap dancing. Jazz. A play. A performer's interpretation of another artist's work — art upon art.

Having a lot of artists in your community predicts success. As urban theorist Richard Florida said, "Metropolitan regions with high concentrations of artists exhibit a higher level of economic development."

Then there are nonprofit arts organizations, which are neither "art" nor "artists." Nonprofit arts organizations don't create art at all. Theater companies, dance companies, symphony orchestras — none of them *create* art. Saying that arts organizations create art is a lot like saying that restaurants cook food.

People who cook food cook food. People who create art create art.

Solving or mitigating your community's needs is not essential. After all, billions of people don't help billions of people every day. But as a nonprofit, a charity whose purpose is to measurably provide a positive impact on your particular community, your duty is to solve or mitigate, not to produce or entertain. Don't get me wrong: the art you produce can be entertaining. But only when you use art to solve and mitigate will you have achieved your nonprofit's objective.

So, your first order of business is to use your resources to ask, interview, and otherwise seek out which problem your

community needs you to solve. Whether that problem has to do with civil rights, homelessness, or potholes (hint: it's not potholes), the solving or mitigation thereof is your company's mission. After that, create measurable ways to show how your art executes that mission. Your mission statement should reflect the need, not the art. For you, art is an unusual and efficient tool to do what? To change what? To solve what? In a truly impactful mission, you would never need to mention that you use art as a tool. The solution is enough.

A mission is not a description of programs you already do. When developing your mission statement (which is the last step in creating a mission, not the first), your team must look at the issues to be handled and promise to solve or mitigate them. When you don't, you propagate the notion that arts organizations simply don't care about the communities in which they live, and, as such, ought not to be funded.

In the first book of this series, *Scene Change: Why Today's Nonprofit Arts Organizations Have to Stop Producing Art and Start Producing Impact*, we noted that, year over year, nonprofit arts organizations continue to see nationwide drops in support, while every other portion of the sector has rebounded from the COVID crisis. After the 2008 financial scandals that led to a major recession, the arts were the last of the sector to rebound from rock bottom, and even then, never quite reached the heights of earlier years.

Why not?

The arts are worth support. On many levels, so are good artists. However, the arts and artists existed before nonprofit arts organizations existed. They'll exist long after nonprofit arts organizations have permanently disbanded. Nonprofit arts organizations have unwittingly (at best) and ruthlessly (at worst) determined incorrectly that the simple production of art is a valid need for the community. As we know now, it is not.

The mission, then, has to send the message that the arts are a means to an end and not the end in and of itself. If your mission is to eliminate homelessness in your community and you have found ways for the arts you produce to make that happen, your company is not only fundable, but heroic.

And that's what good nonprofits are: heroic.

Is yours?

Discussion Exercises/Determine Why the Company Needs to Exist

How high is the barrier to entry for any other arts organization to start up in your community and act as competition for the work that your organization does?

- Nonexistent
- Low
- Moderate
- High
- Denali
- Impossible

Why is it so low? Why is it so high? Are you sure about that?

What would make it impossible, or at least Denali high? Could it be the indispensability factor gained by making all the inroads, connections, and relationships necessary to eliminate or mitigate an urgent community problem? (Hint, hint.)

What is the story of your nonprofit arts organization, beginning to end?

If your founders are still present, perhaps they can help you with the very beginning of this exercise. At some point, you will be delving into an unknown future. What do you want that future to look like?

What was the community like before your nonprofit arts organization existed?

Why did the community decide to allow you to execute the duties of a charity? What, for example, was your first mission statement (you'll find it on the first page of your first 990 tax form)?

Slowly, how did the artistic work link to the health of the community? Was that link measurable, or are you discussing the "nurturing of the soul" or the "community gathering place," neither of which are true charitable outcomes?

As the founders retired, quit, died, or were fired, what personality did the artistic work take on? The new leader's vision? Did that change every time a new leader was hired? Why?

As the scope of your stakeholders (donors, ticket-buyers, staff) increased, how did that affect your art? How did that affect the community? Were your results better, worse, or just different? How so?

As you moved past the pandemic years, what changes did you make to ensure that your company would be essential (or even relevant)? Are there other issues on which you should be focusing in order to help the community?

Later in the 2020s, it will become/became clear that global climate change has radically affected your standing in the community. While your work is neither environmentally friendly nor unfriendly, the art you produce has taken a back seat to the weather, the rising oceans, and other existential perils. How will you change your focus based on that reality?

In the last ten years of your company's existence, what will you have done to cement the relationship you have between producing art for a purpose and the community's health?

When you know when you're going out of business, who will be the benefactors of your work? Another arts organization? How will you choose?

Consider this: imagine that your company has been out of business for 20 years. Write an epitaph — a "tombstone statement," as it were. On the virtual tombstone of the company, what will others describe, in ten words or less, the impact you had on your community? How was your company heroic?

Responsibility #2: Raise the Funds to Pay for Why You Do What You Do

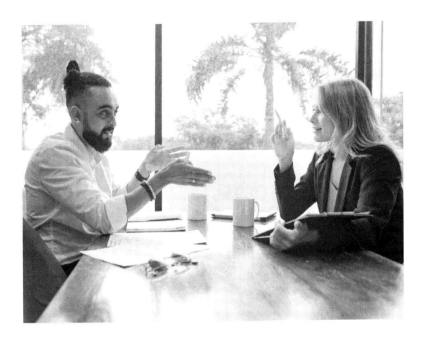

You probably don't think that raising money is your second most important responsibility.

It is.

It is, because no matter who is working for the company, it is every board member's task to make sure money is there to enact your charitable mission (which is your most important responsibility). So, regardless of everything else you do to help the company function well, finding the donations to suit the mission is up to you.

The best/only way to raise the funds necessary is twofold:

1. Increase the quantity and quality of your relationships with those who might have the same interest as you do, and
2. Have the "want-to."

You Don't Need to Bribe or Be Bribed

You don't need an expense budget from your company to set up relationships with like-minded people. In fact, if you have to ask the company for financial support to ask for financial support for the company, you set yourself up for a loop of wholly inappropriate behavior. In the arts, that can get even more treacherous because of the problem that donors are also the beneficiaries of their own donation.

In the business of asking for support, many — if not most — board members seek leverage, rather than help. That might speak to the personality of the connections, the personality of the board members, or the insecurity that what the nonprofit arts organization is doing is not all that important to the lifeblood of the community.

The insecurity can be solved if your mission speaks to a community need instead of honoring or feeding an artist's vision. It is why you need to consider the job description and status of your artistic director. A vision that is artistic in nature but not tangibly helpful to a community in need is a major culprit in the industry's headlong rush to irrelevance.

The test is this: does the vision for the company change radically every time a new artistic director is hired? If the vision is about bettering the community in a specific way, it shouldn't.

Any nonprofit that uses an artistic vision as a guide tends to place that vision ahead of the community's needs, even if the community is screaming for help. When that happens, it's a horrifying act of self-indulgence.

There is a large arts organization on the West Coast that is currently experiencing what most would call its *denouement*. The COVID pandemic sped its inevitable destruction, but it would not have survived the social justice movement nonetheless. That organization, led by good people, has a mission tied directly

to its artistic roots, as though its community were secondary to the art. Exposing people to art is not what the community needed or needs right now.

In the city in which the arts organization exists, there is a homeless problem. Thousands are living on the streets, in parks, in tents, and the shelters are full. The city is working hard to increase housing units in response, but that's a slow process for the people who are homeless right now.

It might be too late for this particular arts organization to recover, although they're doing everything they can to change the way in which they do business to reflect a newfound external mission. However, if its board (much of its key staff has already been replaced) reverts to previous behavior by never asking the community for the answer to, "What do you need us to do?", they might as well close up shop.

If your young son is screaming in pain about having skinned his knee, you don't solve that by singing a song. Even if the performance is superb.

Want-To

"Want-to" refers to the idea that you don't have to gin up interest to ensure the finances of the company. You don't have to be good at the art of the ask — ultimately, you'll hire people who will help you with that. You just need to make sure that those relationships are all teed up, so to speak, for success. Some people have bought into the 21st century notion that isolation is the way to go. To combat the depression and anxiety that accompanies isolation, it might behoove arts organizations to recognize that a successful physical and virtual community requires interaction, not a VR headset. Celebrating that and loudly fighting against the current cultural torrent of isolation is the hallmark of a board member with a "want-to" attitude in seeking financial support.

There are two — and only two — sources for donations for nonprofits: your money and other people's money. Your donation is etched into your board contract, presumably. I recommend that it be among the three largest donations you give to any charity that year. Many nonprofits (of all kinds) expect it to be the *largest* single gift you give in a year. Either way, you must make the personal financial commitment that you have put your money behind a winning proposition. After all, if you don't support your own nonprofit at the highest level, how can you expect the community (or your contacts) to support it at *any* level?

Now, on to other people's money.

As far as "how to raise money from other people," there are literally hundreds (maybe thousands) of valuable resources that can help you do that. I won't go into them here because a good search engine (I use Ecosia) can help you find your local chapter of the Association of Fundraising Professionals (AFP), various support groups on LinkedIn and other professional sites, and maybe even a short-term consultant, of which there are thousands. Don't call a consultant if you haven't completed the most important responsibility, detailed in the previous chapter. They can't help you discover what the community really needs; only you know that.

To summarize, this second most important responsibility is not finding people to raise money. It is finding people with whom you will find it a pleasure to want to raise funds to support a mission. You're not looking for "rainmakers," whose goals are tied to the raising of money. You're looking for "barn-raisers," whose goals are to help build a community in the best way it can and see your organization as a key wall of support to make that happen.

Discussion Exercises/Raise the Funds to
Pay for Why You Do What You Do

How will you increase the quantity and quality of your relationships with those who might have the same interest as you do?

How will you determine if you (and the other board members around you, both individually and as a team) have enough "want-to" to succeed?

Is your donation to the company at least among the three largest you give in a year?

What resources will you use/have you used in helping you with the prospect of cultivating new relationships for the purpose of growing the universe of donors and supporters for the organization? Are you forcing them to do the task for you (rainmakers) or are you finding supporters whose goals are to help build a community in the best way it can and see your organization as a key wall of support to make that happen (barn-raisers)?

Responsibility #3: Take You to Your Leader

The third most important responsibility for a nonprofit board member is to choose the executive director. That said, everything about the relationship between the executive director and the board of directors must change in the Pre-Post-Pandemic Era.

First of all, a key change must take place. Consider firing your artistic director.

An artistic director does not prove your company's worth as a charity, only as an arts producer. Your community does not need an arts producer as much as it needs the benefits that can

come from a well-run charity, even if that charity happens to produce art.

No one cares about Shakespeare, Mahler, or *The Nutcracker* when so much of your community's residents have real needs, as described in the IRS Code, namely "relief of the poor, the distressed, or the underprivileged; advancement of religion; advancement of education or science; erecting or maintaining public buildings, monuments, or works; lessening the burdens of government; lessening neighborhood tensions; eliminating prejudice and discrimination; defending human and civil rights secured by law; and combating community deterioration and juvenile delinquency." None of those things include the production of art.

An artistic officer — on the same level and pay scale as a development, marketing, education, and finance officer — better matches what is required, and allows the executive director to push the art toward the mission and not the mission toward the art, which has become the sad default to so many failing companies.

In the process of choosing your executive director (not "President," not "CEO," and not, as Gilbert and Sullivan put it, "First Lord of the Treasury, Lord Chief Justice, Commander-in-Chief, Lord High Admiral, Master of the Buckhounds, Groom of the Back Stairs, Archbishop of Titipu, and Lord Mayor, both acting and elect, all rolled into one"), a fundamental change in relationship has to take place.

It's time to radically adjust leadership. In a successful nonprofit arts organization in today's normal, the board's duties are monitored by the executive director, not the chairman of the board. So, as we've discussed in earlier chapters, when a board chooses an executive director, it is hiring a boss, not an employee.

In the current iteration of nonprofit arts organizations, there are usually two leaders at the top of the staff portion of the

organizational chart. At least one is an artistic director, a second is a managing director. Their general responsibilities are right there in the titles: an artistic director directs the artistry and a managing director directs the management.

At more than one insecure organization, an artist (or worse, the previous artistic director) serves as a third executive leader. Usually, this is to make sure that the artists win any internal battles 2-1. Two leaders are ungainly and require a great deal of energy to pull off. Three leaders expose organizational weakness, especially in nonprofit terms.

Awkwardness arises when one leader reports to the board but not the other(s). There are still some organizations with structures that indicate that the artistic director reports to the board (because, frankly, talking about art is more pleasant than talking about deficits or renovations). This foments mistrust all around.

The change proposed here is one that appears obvious to other parts of the sector: namely, the programming lead would not be the leader of the organization. Instead, the leader of the mission would have clear power of vetting programming, data gathering, and gauging the efficacy of results while managing board members' ability to use their tools, connections, and education to raise money and further the mission.

The check on the executive director might be a board and staff "vote of confidence" that would either confirm the executive director is acting appropriately and effectively or suggest that the executive director's departure might be the best action for the future of the company. Whatever the mechanism, there must be a check on each level of the company (board, staff members, etc.). However, because the executive director spends up to 100 hours a week being responsible for the stability and growth of the company (with help from the board members, a huge percentage of whom only work for the company a maximum of three hours a month), board members

are in no position to dictate operations or responsibilities. The executive director (who should also be an ex-officio member of the board), provided that they are doing the job for which they were hired in the first place, is the only person suited to serve in that capacity.

To ensure that the board — you — are hiring the best person for the job as the leader of your company, go ahead and remove some of the obstacles in hiring that offer the company more protections than the leader. The biggest bugaboo, for example, is the "employment at will" clause.

The United States is the only major industrial power that maintains a general employment-at-will rule. If a leader with purpose is going to take a chance on engaging the skills it requires to make your organization work, that leader can't be held hostage to discharge for no reason. If you want to have a 90-day probationary period, that might be acceptable; but then again, that 90-day period may cause a hugely talented potential leader to balk. The negotiation is up to you.

The contract for the person you hire should be for at least one year and completely guaranteed. If that person is coming in from another city, two years might be a more reasonable minimum. In other words, assuming there is no probationary period issue and the leader is serving ethically and in good faith (regardless of your personal opinion), the entire year's salary must be guaranteed as long as the termination is not wrongful. Each new contract should be negotiated no less than four months ahead of the expiration date so that both you and the leader can make plans for the future.

This protects both sides. You're protected because, as long as the contract is exclusive, the leader cannot take a new job without your permission, without that leader owing you for the balance due. And, of course, the leader is protected from you finding someone more sparkly, because then, you would owe the leader the balance, regardless of everything.

In today's world, when there is no such thing as 40-year loyalty (and why would there be?) in employment circles — on either side of the table — hiring your boss is the best way to ensure that the charitable mission of your company is worthy of the best people available. That person is far likelier to lead you to success, a better community, and the solution of the issues plaguing your community than you are (at three hours a month), or an artist that believes that their vision is more important than the community itself.

Discussion Exercises/Take You to Your Leader

Create your preferred organizational chart. What characteristics do you require for a new executive director to lead the company (and you) to its greatest impacts?

Have you fired your artistic director yet? Why not?

If you're having trouble envisioning what a nonprofit arts organization whose intent is to solve or mitigate a community issue might look like, take a look at this beginning of an organizational chart. Devise one of your own, removing the artistic leader as the person in charge of the impact of your organization and putting that artist alongside the other important officers of the company, all of whom report to the executive director.

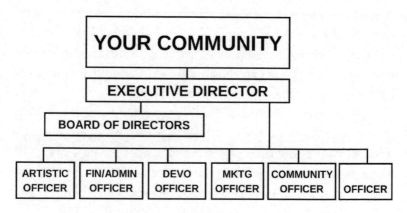

Does this chart make you uncomfortable? Why? Do you currently have a 2-leader system and see nothing wrong with that? In practice, is there such a thing as an equitable 2-leader system? Then why don't most companies, foundations, governments, and non-arts nonprofits adopt one?

What does an ideal contract look like for an executive director?

Construct a *changeable* template for an executive director's contract. Remember this: there is no such thing as a "standard contract." If anyone presents one to a candidate and calls it that, a savvy candidate — the kind you want — will walk away.

What advantages does the active elimination of the "at will" provision of a contract do to show faith and trust to both sides? If you are in partnership with a leader, why disadvantage that leader in any way?

Are you seeking team growth or do you need a power play? What provisions determine that the best team — including board members — is "on the field" at all times?

Do you require a probation period, even for those coming from out of town to take the position? What is the compensation for sending the candidate home after that period but before the contract expires?

Is the contract a boilerplate from an HR expert that happens to be on your board of directors? Has that HR expert created contracts for leadership, or just re-created existing contracts? Has the HR expert ever hired someone in a nonprofit position? What have been the benefits and pitfalls of previous contracts?

Can you create a contract that is non-adversarial? If it is signed with no discussion by the candidate, is that a good sign that the candidate has a strong negotiating power? Similarly, if it is signed with no discussion, will you feel as though you've "gotten away" with something?

Discuss the entirety of the hiring process. How long do you plan to take? Who will conduct interviews? Will there be a zombie interviewing squad with pre-printed questions, or will it be a guided, open-ended conversation with the candidates? How much input will other staff have?

Ultimately, this is yet another consensus decision-making process. No matter whom is selected, the amount of input from others directly affects how much buy-in they have for the job. If you ask your staff, for example, to conduct a round of interviews, and they recommend someone that the board does not recommend, do you believe the staff will leave *en masse* because you picked someone else? Are you sure?

Like a new board member during a board meeting, stakeholders involved with the hiring process have to be considered. Does that mean that every stakeholder has to be part of the process? Probably not, although it depends on the level of trust they have concerning the board of directors. Do you have their trust?

Responsibility #4: Find Others — Especially If They're Not Like You At All

You now have to put yourself out there to connect to, recruit, and persuade others to become board members.

Even when you have nothing in common with them, except a love for the community.

Even though some may turn their backs on you and walk in the other direction when you approach them.

Even when there is no *quid pro quo* involved ("I'll join your board if you join mine.").

Even when — no, *especially when* — the time has come for you to rotate off or permanently leave the board.

I get it. No one likes to spend personal capital. Politically speaking, it puts you in a position of weakness. If you want someone to do something, even if it's for the community in which both of you live, the leverage is with that person and not you.

Interestingly, the most underserved in your community would agree with you. Except that they're more likely to die because of the lack of leverage. Not die of embarrassment, as you may believe you will by putting yourself out there. Just die.

As you search, keep a few things in mind, in no particular order.

A Major Donor Is Not Necessarily a Good Board Member.

Often, people will try to buy themselves a board seat by making a large donation to the arts organization. Just as often, people will show their support by writing a big check, causing members of the board to whinny in anticipation of bringing them on as a new board member. But, just because someone loves your organization's work does not make them a board member. It doesn't disqualify them, of course, but try to look beyond the dollar signs to the intent of the donation. If the donor is toxic — not many are, but too many are — and wants to use their power to set up an exclusive party room for themselves and their friends inside your venue, for example, then their donation is tainted by the grasp for control, disqualifying them from collegial membership.

And that's okay. Not everyone is qualified to be a board member for your organization.

Right?

Find People Who Do Not Look Like You, Especially When You're Leaving.

This is generally a tough task. After all, most of your friends and family, largely speaking, look like you.

If your board is massive and unwieldy and you haven't already pared it down, it is still important to find new board members to sit with you and serve the community. More

nonprofit arts boards are having trouble with keeping their size intact. You'll always be looking for new members who can make a difference for the community you serve.

No board appointment is permanent. Indeed, if you're smart, you'll not only have term limits to membership, but you'll insert a rule that once someone has served one term as the president/chair of the board, their board service is complete. No one wants to be the president of a board that has a whole bunch of ex-presidents kibitzing about how things were better in the old days when *they* were president. Selective memory serves as an untrustworthy and threatening weapon.

Also, an emeritus board — a mushy compromise catch-all intended to keep key people involved, such as the retiring chair, the founder, or a major donor — is a bad idea, even if someone's name might mean something in your community. Remember: you don't have to be a board member to serve on a committee or place a phone call on their behalf. Keep it unofficial.

In any case, if you are leaving the board for any reason, it is your responsibility to find a new kind of replacement of equal value.

Find People Who Know How to Serve as Well as Lead

In a nonprofit arts board, there is often an undercurrent of well-meaning (but ill-advised) tension toward the company's business practices. Most of the time, this comes from a lack of experience or knowledge of how charities work.

If someone believes that and chooses to serve, it is almost always a case of wanting to "fix the problem." Disabuse them of that notion. The answer to all business practices comes down to one thing and one thing only: the mission. Mitigate a problem in the community and your nonprofit is successful. Don't and it's not.

To wit: if 90% of expenses go to the programs but the community has not reaped any measurable benefit (e.g.,

mitigating homelessness), the company has failed. Similarly, if 50% of expenses go to the programs and a measurable benefit does occur, the company has succeeded.

I wish funders would get that. Too many don't, even when this "overhead myth" was exposed as such by the major charity evaluators (Charity Navigator, GuideStar, the BBB Wise Giving Alliance).

With the executive director piloting the organization, it is imperative that the board members not only know how to lead the charge in the community, but serve the organization's plans to do so. No one board member is more important than others in that cause.

When You Bring Someone onto the Board, You Have to Listen to Them.

A board is not a club. It's not a clique. It's an organism of change and support.

Think of it this way. Let's say your nonprofit arts board looks like this:

And your community, well, doesn't.

Will each new board member have the same power, rights, control, and freedom to make decisions as you do? Even if they don't look, sound, or have the same background as you? Can you live with the changes they make for the sake of the community?

Or will they just check a box on your DEI program?

And then, if they become too powerful for your taste, all for the sake of the community, will you resign your board membership because the company isn't what it once was?

Don't let this be you:

I WANT MY PRIVILEGE BACK!

There Is No Kids' Table at a Board Meeting

Every board member is equal to every other board member, regardless of how long they've served. Longstanding board members have no additional power, no matter how long they've been there.

New members are not required to play by their rules. Otherwise, why would they want to help?

It follows, then, that it is more important for experienced board members to listen to new board members than the other way around. If a path requires a shift, the newer board members are more likely to speak to it than those who might be entrenched in a status quo. That's a good thing. That's why they're there.

There are myriad resources available about how to enhance your nonprofit arts board. When you read them — and you should — remember these important ideas. It won't all go swimmingly. Sometimes you'll choose the wrong person; sometimes the wrong person chooses you. That's life. Make sure you've made arrangements — a quasi-prenup, perhaps — to protect the community.

Discussion Exercises/Find Others — Especially If They're Not Like You At All

Who deserves to be on your board of directors? Does your board of directors deserve an exemplary candidate? Determine what your board members should do, be, and represent.

Are you able to recruit well? What might be standing in the way?

Do you have specific requirements for your board members? Is there a contract that reveals *all* of the responsibilities?

Do you have term limits? What happens at the end of each term? Is every board member deserving of term renewal when eligible? Do they get it anyway? Why?

How will/do you evaluate each board member? Is it annually (when there's little time to do anything about it)? Or is it constantly? Who evaluates? The executive director? The board chair? A committee created just for that task? All of the above?

Does every board member look like every other board member? Regardless of the answer, what part does inclusion play in your recruiting process? Are you looking for great people or are you ticking little DEI check boxes?

Do new board members have equal power to old board members? Are there harmful cliques within the board, reminiscent of a bad high school student council? Why or why not?

Does every board member know that they have to personally give money to the organization, regardless of how much time they spend? Do they have to be chased down every year for their donation?

How is your underserved community represented on your board? Do they have a say on how your nonprofit arts organization can help them and those like them?

Does a major donor automatically get asked to be on the board? Was their gift "major" for them or for you? Are they trying to buy their way onto the board? Are you selling a seat? Why?

What happens to board chairs after their term expires? Do you roll them off the board to clear the way for the next chair ("No one wants to be the president of a board that has a whole bunch of ex-presidents kibbitzing about how things were better in the old days.")?

Are you going to limit your growth by creating an emeritus board whose members include ex-board members, founders, ex-staff, and other people who may drag down progress with "we do it this way because we've always done it this way" albatrosses?

Is your board a club or does it have a job? Do you take actions suggested by the newest, more "diverse" members of the board, those who you begged to come on to show the community your new commitment to DEI? Or are they token members?

Do you have a board agreement "prenup" for when things don't go swimmingly?

Responsibility #5: Be a Zealot, Not an Ambassador

Advocate.

Advocate *zealously*.

Board members are not ambassadors, regardless of what you may have heard. They are zealots.

In hiring practices, wouldn't you seek passion from your executive director? From your performing/exhibiting artists? Administrative artists? Volunteers? Then why would you accept anything less from a board member, the one whose influence and connections can make or break the finances of the organization?

Simply put, you wouldn't — and you shouldn't. So don't.

Don't stop at being a supporter. Or a fan. Or even a champion of your nonprofit arts organization. If the neediest people in your community are truly better off (in quantifiable ways) by your company doing its best work, it is not enough to be happy about it. You've got to tell people about it. Again and again.

Put the Organization at Top of Mind and Tip of Tongue

It's not a tough concept if you truly believe in the results. If people are being housed or fed or in some other way made more whole because your nonprofit arts organization is making it happen, the knowledge thereto will not just magically happen. You have to make relationships happen, not just let them happen, in order for your zealotry to be considered successful.

"Zeal" is usually a word reserved for Christianity and a few other religions. But the dictionary definition is this: *"Great energy or enthusiasm in pursuit of a cause or an objective."*

Nonprofits are physical manifestations of causes. Your arts organization is no different. Read this list of synonyms for "zeal":

Passion, committedness, ardor, love, fervor, fire, avidity, fondness, devotion, devotedness, enthusiasm, eagerness, keenness, appetite, taste, relish, gusto, vigor, energy, verve, zest, fervency, ardency.

If you don't like "zeal," pick one of those.

Do you see how "ambassadorship" pales in comparison? Ambassadors are people who have been appointed (usually as some sort of politically expedient quid pro quo) to represent a country in an embassy. They sit behind desks. An ambassador waits for those who need them, and then often says, "No."

A zealot, on the other hand, does not wait. A zealot, especially one with a cause, goes out and drums up support.

A zealot does not accept the word "no." If a cause is just, the zealot leads the charge toward the word "yes."

That's what your organization needs, especially if you've decided to do the right thing and help your community in its most dire needs. If the organization you represent, however, chooses to put on entertainment and, as such, is indistinguishable from its for-profit version, then zealotry would look foolish and elitist.

So don't do that.

Fix the issues of your community, and regardless of what you put on display, you'll receive support forever. Tell your boss, the executive director, that you want nothing less than measurable results. Otherwise, how can you go out and get people to help your cause?

Zeal Requires Action, Unless You Don't Want to Do It

If zeal is not your thing, then go ahead and become the for-profit version of your art. There's no shame in that. Broadway does it. Vegas. Branson, Missouri. Casino shows. Jazz concerts. Private galleries. All forms of television, video, and streaming are commercial art forms. All completely respectable. The key difference is that a for-profit commercial venture does not vacuum money away from real charities, as a nonprofit arts organization with no community mission too often does.

If you are on the board of a nonprofit organization, even an arts organization, you are at the forefront of a movement, not a country club. Fed, housed, clothed, educated — whatever the primary intent of the company, it's your job to get everyone on board. Your task is to trumpet the organization and its indispensable impact on the people in your region.

Mention your company at every gathering, regardless of the subject of the gathering.

Mention it at lunch. At dinner.

Mention it when you have a business meeting. People like passion; it will serve you well.

Know everything there is to know. Get your boss (the executive director) to help you with that.

Write letters: to the editor, to your congressperson, to your mayor.

Give more than three hours per month. Give ten. Give 20, especially if those other hours are used in service to the zeal.

See every event. On the first day. Even if you get crappy seats. Know why and how it helped people in the community. Meet the people who were helped. Get their stories and pass them on.

Zealotry will not turn people off if it is genuine. If it is not from the heart, you'll come off as a snake oil salesman. And if you *are* coming off as a snake oil salesman, you probably don't have faith in the work your company is doing.

Let's put it this way:

Either find a way to believe … or find a way to be leaving.

Discussion Exercise/Be a Zealot, Not an Ambassador

What does "zeal" mean to you, and how can you apply it to your activities as a board member of a nonprofit arts organization?

Responsibilities 6 through ∞: Learning and Governing, Among Others

Obviously, there are more than five responsibilities for a nonprofit arts board. The other responsibilities all have to do with learning and governing. They have to be done, but your nonprofit arts organization is no better off even if these things are done with exceptional aplomb. Think of these things as binary activities. Done or not done. There is no prize for "done well."

Learning

Learn everything you can about your nonprofit.

Learn about the other board members, the staff members, and the key donors. Thank them for what they do, but make sure what they do is to maximize the effectiveness of the organization's duty to your community. Learn which tools everyone is using

to measure success; discuss whether the community is getting better by those measurements. Learn what other charities are doing to help your community solve similar issues. Learn what other arts nonprofits across the country are doing to help their communities solve similar issues.

Like anyone else in the business community, don't accept "we've always done it this way," or "this is the way everyone does it" or — the worst — *"best practices"* as an explanation for bad behavior. You might find that "best practices" might have been correct yesterday, but not today. Look up the history of hysterectomies to uncover what "best practices" has done to humanity at times when experts really meant well. (It's pretty gruesome.)

Learn about the HR practices, conflicts of interest, and other bugaboos that might compel you to act as a referee. Learn how to read a balance sheet and a P&L statement. Don't just say, "I don't know how," and let someone else do it. It's not hard. It takes less than an hour.

Ask questions about the budget long before you are compelled to vote on it. Before you do, learn about "The Overhead Myth" and how it harms nonprofits who depend on funding from foundations, corporate donors, and government sources that require that a certain (usually incredibly high) percentage of the revenues go to "programs," however that is loosely defined.

Find a way to disabuse those funders from that impulse; it makes no sense. To repeat from a previous chapter: if 90% of expenses go to the programs but the community has not reaped any measurable benefit (e.g., mitigating homelessness), the company has failed. And again, if 50% of expenses go to the programs and a measurable benefit does occur, the company has succeeded.

Don't pass a budget if you have problems with it, but, of course, if the budget passes, do everything in your power to support that decision.

Learn about what it means to work as a team and not as a collection of lone wolves. Follow the orders that the executive director may provide, but not blindly. Ask "why" questions if something doesn't seem right to you, but then, after you're satisfied with the answers, it's time to go forth and succeed the best way you can.

Governing

You don't have to spend all that much time in governance, except to read and understand the financials, abide by the bylaws, and make sure that no board member, staff member, donor, foundation, community member, volunteer, audience member, or public official is bamboozling you.

Governing is an odd word for board members. At three hours a month, it's difficult to govern, except as a dilettante. If someone were to make an unpopular decision based on such little time and effort paid to the company that provides your salary, you'd be pretty upset, and rightly so. Therefore, the most important thing you can do to convey your governance properly is to follow this advice.

Heats of moments, castle intrigue, or unexpected power plays are the subject of art, not the governance of it. Surprises are the outcomes of lack of communication, toxicity, and misplaced blame. Don't make decisions that way. If a board meeting turns into an uprising, that means that there is a severe disconnect.

If the pandemic taught nonprofit arts organizations nothing else, it's this: the best way to *seem* essential is to *be* essential. Indispensability will not only keep your nonprofit arts organization from dying of irrelevance, you'll become community heroes before the first note is played, the first word is spoken, or the first exhibit is open to the public.

Artistic excellence, which is subjective (and therefore a meaningless metric), really doesn't matter. Flexibility matters. Impact matters. Solving a problem matters. Do what is right

for your community, not what's convenient for you, and you'll have a better chance of thriving. And, of course, so will your community.

The Scientific Method ... It Works!

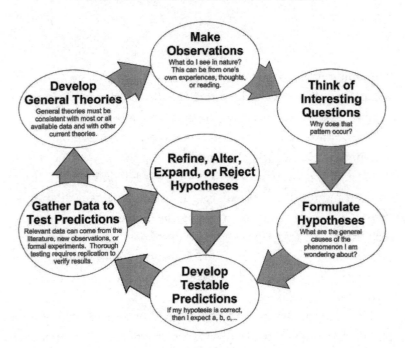

All nonprofits are essentially scientific, social experiments in bettering our various lots in life. Including nonprofit arts organizations.

The background of your nonprofit experiment is this: there is a thing that needs to be done or else the community suffers. Private businesses can't do it. The government either can't do it, won't do it, or are prevented from doing it by opposing groups. It's up to you.

The experiment, then, unfolds to a proposal, for which the Scientific Method — yes, that thing you learned in middle

school science class — may be used to solve. The question that kicks off the process becomes, "Can my nonprofit do [insert a highly needed thing to support the community] by taking on tasks that no one else can do efficiently?"

A hypothesis that answers, "Yes, and here's how…" becomes the complete menu of programs for the nonprofit. You sit on the board of a nonprofit arts organization. Your job is to make sure everything is done so that the result of the activities quantifiably betters your community.

Sometimes the answer is "no," at which point you either start over with a new set of activities or ask someone else to do it.

Use the Art You Produce as a Means Toward an End, Not as the End in and of Itself. Insist on It.

Don't be wowed by artistic presentations at board meetings. Spend each board meeting as if it were a retreat; expenses spent on the future are far more effective than expenses spent on things over which you no longer have any control.

Be alert and flexible, and your board will succeed in its role of making your community a better place to live.

Or, if the collected data from your Scientific Method experience reveals indications otherwise, not. If that happens, either go back to the beginning with a new hypothesis, or give the reins over to those who will. Prepare neither to succeed nor to fail. Just follow the data.

Wrapping It Up — Don't Wrap It Up

So there they are, the five-plus real responsibilities for nonprofit arts board members. This is not an "all-time" list, of course. This is a "now" list. Time acts as a key variable in all of these kinds of lists. Times change, to say the least. And they will change again, after which you may want to revisit your list of responsibilities to sync up with that change.

Curiosity is a determining factor for success in any field. If you believe you already know as much as there is to know, then you're probably a fool. Nobody wants a fool on their board.

This book does not purport to be the answer to all your prayers. Any publication, consultant, executive director, board member, school, or any leader that believes that they have "The Answer" resembles Deep Thought, the planetary supercomputer in the book, *The Hitchhiker's Guide to the Galaxy*, whose answer to life, the universe, and everything is "42." Like this book, that answer is only comprehensible in context, so please enjoy the epilogue (or is it epilog?), which is coming up after these last discussion exercises.

Discussion Exercises/Responsibilities 6 through ∞: Learning and Governing, Among Others

"The Overhead Myth"
Do you understand why "The Overhead Myth" is called what it's called?

Take time to discuss the "Overhead Myth." For more information, visit the TED Blog called *Correcting the overhead myth: How Dan Pallotta's TED Talk has begun to change the conversation*, which you can find at https://bit.ly/o_myth. Then, discuss how your company is going to proselytize that information to foundation, corporate, and government leaders to help the rest of the sector as well.

Don't forget to apply the Scientific Method to your organization!

Epilogue

You don't have to follow what others call "best practices" if it doesn't work for your community.

If you are a nonprofit arts board member, you have a chance to build something great. And no, the best way is not to copy what your fellow arts organizations are doing. In fact, it might behoove you to look at other kinds of nonprofits that fit under the IRS guidelines.

If you have your 501(c)(3) letter, you are a nonprofit. That is not in question. It would take an act of severe bad faith to lose that status. Severe, as in criminal. The IRS is not checking up on whether your organization fits within their status descriptions. You know that already. In fact, you're banking on it. You're skating on not-all-that-thin ice because no one will stop you.

It's like driving 70-mph in a 60-mph zone (or, say, 120-kph in a 100-kph zone), assuming you're driving sober and are awake at the wheel. No one's likely to stop you. In fact, you can justify your speed (in your head) by determining that everyone else is going 70/120 as well.

The thing is, driving above the speed limit increases the likelihood that if you should crash, you will die. That's why the speed limit was set at 60/100 in the first place.

And so you keep presenting art. Maybe it's for art's sake, even though you may not understand what that means and why it's irrelevant. Maybe it's for your artistic leader's sake, although you never quite understand their decision-making processes. And people buy tickets or donate or whatever, and you're generally happy about that. The IRS isn't coming after you.

But what we've come to learn, especially after many, many years of economic downturn for nonprofit arts organizations, is this: the best way to seem essential (and fundable) is to be essential (and, therefore, fundable). To be essential — driving the speed limit — may not be all that exciting for the artists. But it's what the community needs. And it will not only keep your arts organization from dying of irrelevance, it will likely thrive instead.

The generations of donors who gave to arts organizations as a form of civic rent are either dying or have already died and their kids and grandkids aren't rushing in to fill the support gaps. So, if you are depending on your 80-year-olds to save you, that is not a good plan. Maybe you don't care if the industry expires in a few years. Artists existed and created art long before arts organizations existed to produce art. And they'll exist and create long after the sector has vanished.

If you believe in your charity, isn't it your responsibility to both speak for the community to your organization and to speak for your organization to the community?

So the question arises: what does your community want and what does it need? If there are no reports that say that your organization's productions solve any community problem except for the lack of your organization's productions, that means your work is irrelevant. That's almost the dictionary definition for "irrelevance."

What might help you, then, is the knowledge that your board need not fit some precedent in performing its tasks. "The 5 Most Important Responsibilities of a Nonprofit Arts Board Member" need not take the form of a group of people sitting around a boardroom table.

You can do anything you want, within reason and laws and rules. There are lots of kinds of boards. Your board needs to adapt to your community, not the other way around. It shouldn't be limited to serving some long-standing predetermined dog-and-pony show. Just serve the community first by using the arts as a tool, not as a final product.

There are lots of kinds of boards.

In the state of Washington, your board is required to have three people on it, following the lead of the IRS. Evidently, that's true in a lot of states. Beyond that, there are other rules of incorporation that determine what you have to have in the formation of your nonprofit corporation. There are the bylaws, which are by no means "standard."

Those three people might be the only board members you need. And if you have them report to the executive director (an ex-officio, fourth member of the board), the new leaders you recruit might be more effectively used as members of fluid task forces. Or, you can have a 100-member board (not recommended by me, but maybe by your community) in which your board members handle the five responsibilities in waves, like directing a high school play with 165 kids in it.

Maybe meeting once a month is too arbitrary. In a 3-person board, maybe it's better to set up your committees and task

forces to report based on the project they're doing; maybe every Friday. In a 100-person board, maybe it's best to make a rule that tasks an executive committee to handle all parliamentary requests. For that size, maybe once a year is plenty.

Maybe the military-based *Robert's Rules of Order* board is right for your community. But if it's the only way you've ever tried, perhaps it's time to expand your thinking to find exactly the right fit for you.

It's totally up to you.

It's easy to copy what others are doing, regardless of effectiveness. It's more difficult to fashion a board that works exactly for your community, but the point of engaging in the exercise is to increase effectiveness in solving or mitigating your community's problems, as you have promised to do.

There is a movement afoot internationally to resize, reduce, and reimagine boards for nonprofit arts organizations. If your arts organization is doing nothing except producing art, your board of directors probably ought to be resized, reduced, and reimagined … if not replaced. Or removed.

When you know that your nonprofit arts organization is a scientific experiment instead of a production company, I think you'll come to learn that the higher the human stakes are, the more vital the community will see you. Changing the direction of your board will not only seem like an obvious thing to do, but an exciting one. As former US Army Chief of Staff Eric Shinseki once said,

If you don't like change, you're going to like irrelevance even less.

Why Do All This?

The world around you is evolving quicker than ever. That fact alone might lead a timid arts organization to eschew its responsibilities as a positive, measurable influence on the place you call home. A warning: any organization that chooses not

to take advantage of its "Golden Ticket" charitable status to become indispensable will likely be falling by the wayside as they tout the so-called "excellence" of their presentations of art. If that's you right now and you have no plans to change, get the "we're going out of business" press release ready.

The good news is this: you now know differently. You know what it will take today and in the coming years to become a truly *essential* arts organization, crucial to the success of your community. You can now make a difference in solving or mitigating your community's biggest problems with your arts organization. You have the power to eliminate elitism and bad practices from an otherwise failing industry. As such, you are at the forefront of a great movement, ready to become a community hero.

The arts have been an elemental part of my life for 30 years. I'm rooting for you.

Be the hero you were meant to be.

Related Books. Read Them All, If You Can. And More.

Harrison, Alan. *Scene Change: Why Today's Nonprofit Arts Organizations Have to Stop Producing Art and Start Producing Impact.* Changemakers Books, 2024. Duh.

Collins, Jim. *Good to Great.* Random House Business, 2001.

Collins, Jim. *Good to Great and the Social Sectors.* Harper Collins, 2005.

Greer, Lisa. *Philanthropy Revolution: How to Inspire Donors, Build Relationships and Make a Difference.* Harper Collins Publishers, 2023.

Ingram, Richard T. *Ten Basic Responsibilities of Nonprofit Boards.* BoardSource, 2003.

Sinek, Simon. *The Infinite Game.* Penguin Business, 2020.

Sinek, Simon. *Start with Why: How Great Leaders Inspire Everyone to Take Action.* Penguin Business, 2019.

Strauss, William, and Neil Howe. *The Fourth Turning: An American Prophecy.* Broadway Books, 1998.

Wooden, John R., and Steve Jamison. *Wooden: A Lifetime of Observations and Reflections On and Off the Court.* Contemporary Books, 1997.

Zheng, Lily. *DEI Deconstructed: Your No-Nonsense Guide to Doing the Work and Doing It Right.* Berrett-Koehler Publishers, Inc., 2023.

About Alan Harrison

Alan Harrison is the author of *Scene Change: Why Today's Nonprofit Arts Organizations Have to Stop Producing Art and Start Producing Impact.* He is a father, writer, stage and film actor, nonprofit executive, cabaret piano player (but not a good one), composer, playwright, singer, columnist, critic, voice actor, association executive, and an arts-related board president (in no particular order).

For the past 30 years, he has led, produced, directed, promoted, raised money for, succeeded in, and failed in over 300 theatrical productions on and off Broadway, and at prestigious (and not-so-prestigious) nonprofit arts organizations across the United States. Among those organizations were Lincoln Center Theater, the Los Angeles Theatre Center, the Pasadena Playhouse, Pittsburgh Public Theater, Seattle Repertory Theatre, the Alabama Shakespeare Festival, and ArtsWest, where, under his leadership, the company won awards for Best Nonprofit Place to Work, and Theatre of the Year.

Along with writing books, Alan speaks to various arts-specific audiences on the power of choosing to become a charitable organization that happens to use art as a tool. He has spoken at conferences, on podcasts, and in boardrooms about the power they have to save themselves from themselves.

He has a terrific son, Danny Harrison, and a partner in crime, Donna Oslin, both of whom keep him in check ... and stitches.

Oh, right. He's also a two-time *Jeopardy!* champion so, you know, there's that.

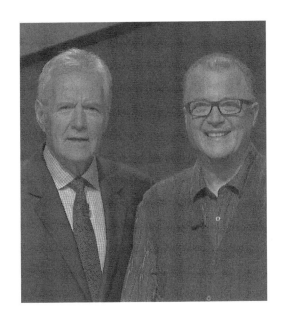

A Special Note to You, the Reader

Thank you for purchasing *Scene Change 2*. I hope you've also picked up a copy of the first book in the series, *Scene Change: Why Today's Nonprofit Arts Organizations Have to Stop Producing Art and Start Producing Impact*. My sincere wish is that you derived as much from reading this book as I have in creating it. If you have a few moments, please feel free to add your review of the book at your favorite online site for feedback. It helps to get the message out about the future of nonprofit arts organizations.

Also, if you would like to connect with other books that I have coming in the near future (*Scene Change 3: Why Arts Nonprofits Can Succeed* is tentatively the next title in this series), please visit my website for news on upcoming works, recent blog posts, and to sign up for my newsletter. On the site, you'll find easy ways to contact me about the issues you might be facing within your own nonprofit arts organization. If you have noteworthy nonprofit arts organization stories — horror, glory, or funny — which you'd like me to share, I'd be delighted to chat.

Sincerely,

Alan Harrison

Website: 501c3.guru

CHANGEMAKERS
BOOKS

Transform your life, transform our world. Changemakers
Books publishes books for people who seek to become
positive, powerful agents of change. These books
inform, inspire, and provide practical wisdom
and skills to empower us to write the next
chapter of humanity's future.

www.changemakers-books.com

Printed and bound by CPI Group (UK) Ltd, Croydon, CR0 4YY

11/11/2024

01787038-0007